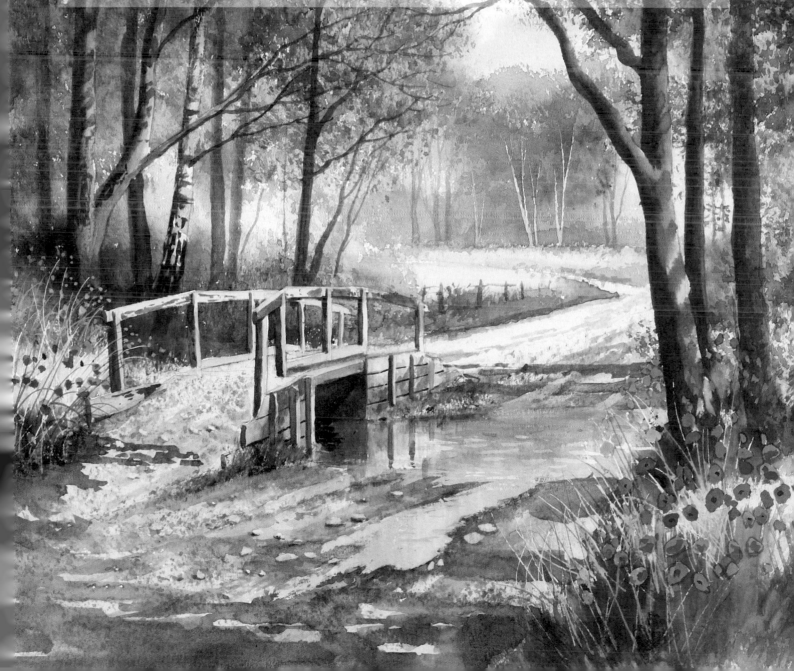

Painting
WATERCOLOUR
LANDSCAPES
the Easy Way

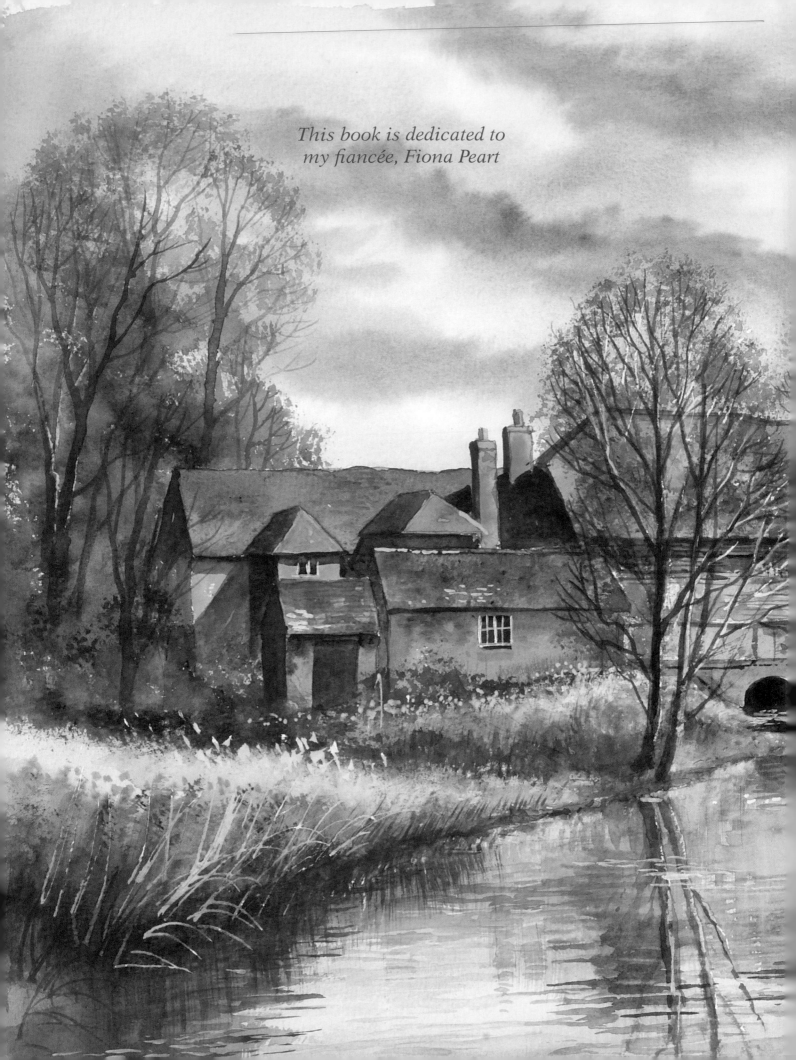

This book is dedicated to my fiancée, Fiona Peart

Painting
WATERCOLOUR
LANDSCAPES
the Easy Way

Brush With Watercolour 2

TERRY HARRISON

SEARCH PRESS

First published in Great Britain 2010

Search Press Limited
Wellwood, North Farm Road,
Tunbridge Wells, Kent TN2 3DR

Text copyright © Terry Harrison 2010

Photographs by Roddy Paine Photographic Studios
Photographs and design copyright © Search Press Ltd,
2001

ISBN: 978-1-84448-464-5

The Publishers and author can accept no responsibility for
any consequences arising from the information, advice or
instructions given in this publication.

Suppliers
If you have any difficulty obtaining any of the materials
and equipment mentioned in this book, please contact
Terry Harrison at:

Telephone: +44 (0) 1451 820014

Website: **www.terryharrison.com**

Publishers' note
All the step-by-step photographs in this book feature
the author, Terry Harrison, demonstrating how to
paint landscapes in watercolour. No models have
been used.

Page 1: Old Bridge, New Forest

*Many of the techniques and brushes described in
this book have been used to create this painting. I
used masking fluid on the main features such as
the bridge, water and flowers and some of the trees
in the foreground, and the distant tree trunks were
scraped out with the px handle.*

Pages 2/3: High Mill near Farnham

*I remember painting this scene when I was at art
school in my teens, (so not that long ago!). The
place has not changed much over the years, but
my painting style has. If only I had known then
what I know now!*

Printed in Malaysia

*Writing a book is not easy so it helps to
have people around you who know what
they are doing, true professionals at
the top of their game (like myself!). But
seriously, my sincere thanks to my editor
Sophie Kersey for once again keeping me
on the right track with this book.*

*Thanks also to Gavin Sawyer, the
master of step-by-step photography.*

*I wish Search Press continuing success
and thank them all for their support over
the years; they are a great team
to work with.*

*The big thank you goes to my fiancée,
Fiona Peart, for her practical, physical
and spiritual guidance, which helped in
the making of this book.*

Opposite: Gone Fishin'

Contents

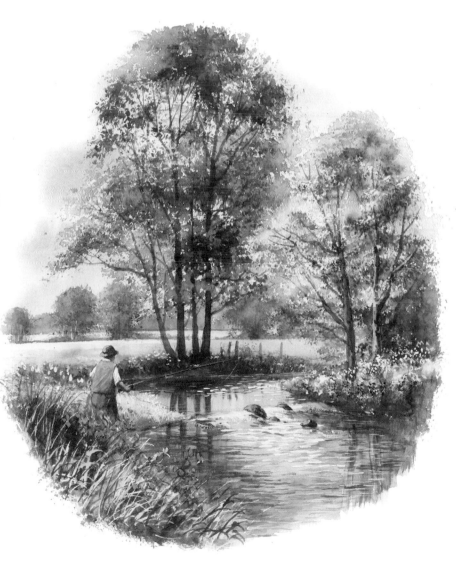

INTRODUCTION

If you are reading this book you must be interested in painting in watercolour and looking for an easy way to do it. If only I had had this book when I first started. The few books I had were written by very talented artists I am sure, but as a beginner, I found them extremely difficult to understand, so I have written a book that I would want to read. This is about how to use brushes, what colours and materials to buy, and how to master techniques such as wet into wet, wet on dry, dry brush work, and using masking fluid without coming unstuck!

Most of the techniques in this book are achieved using my own range of brushes, which have been designed to create different effects, allowing you to paint textures, foliage, trees and water the easy way. This book is like a user manual for my specialist brushes. It works for me, so it should work for you.

The first brush I designed was the fan gogh. I could not find a fan-shaped brush that did not separate into spikes when dipped in water, probably because these brushes were originally made to blend oil paints, rather than to apply paint. Eventually I found a brush company who were willing to listen to my needs, and the fan gogh was born. Other brushes followed – I would explain what I wanted a brush to do, and after many trials and prototypes, a new brush would be developed.

The next step was making the Three Greens, my own range of ready-mixed green watercolour paints. Now let's be honest, it is not easy to mix greens; if it is that simple, why do so many artists mix mud? The easy way is to use ready-mixed greens.

It's all very well learning new techniques, but what do you paint? Hopefully this new book will tempt you to have a go at some of the step-by-step demonstrations, or copy some of the many beautiful paintings I have done especially for this book. Not long after my first book *Brush with Watercolour* was published, I asked an American why she liked the painting on the front cover so much. Her answer really struck home – she said, 'It's a place where you would want to be.' I hope that reply will inspire you as much as it inspired me.

Opposite
The Ferryman's Cottage
The lock keeper's cottage and river might be enough to make this tranquil scene a successful painting, but adding the boats in the foreground creates a different story and suggests the ferryman of the title. The flowers on the riverbank add colour and this can then be reflected in the water using the emperor 19mm (3/4in) flat brush.

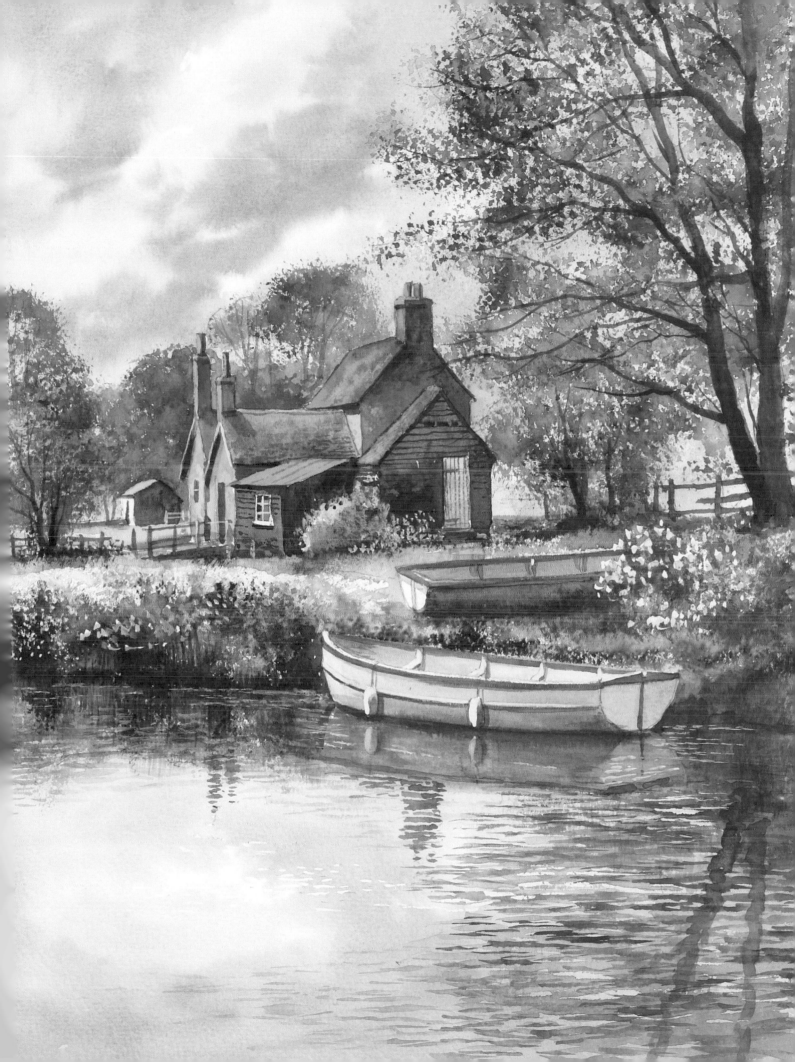

Padstow

This popular Cornish harbour is famous for its fish restaurants and Cornish pasties on the quay, but it is not an easy place to paint. The old buildings are mostly built from local grey granite and can be painted using the foliage brush to create the textures. The half-rigger is an ideal brush for adding the detail on the windows and harbour wall, and of course the rigging on the boats.

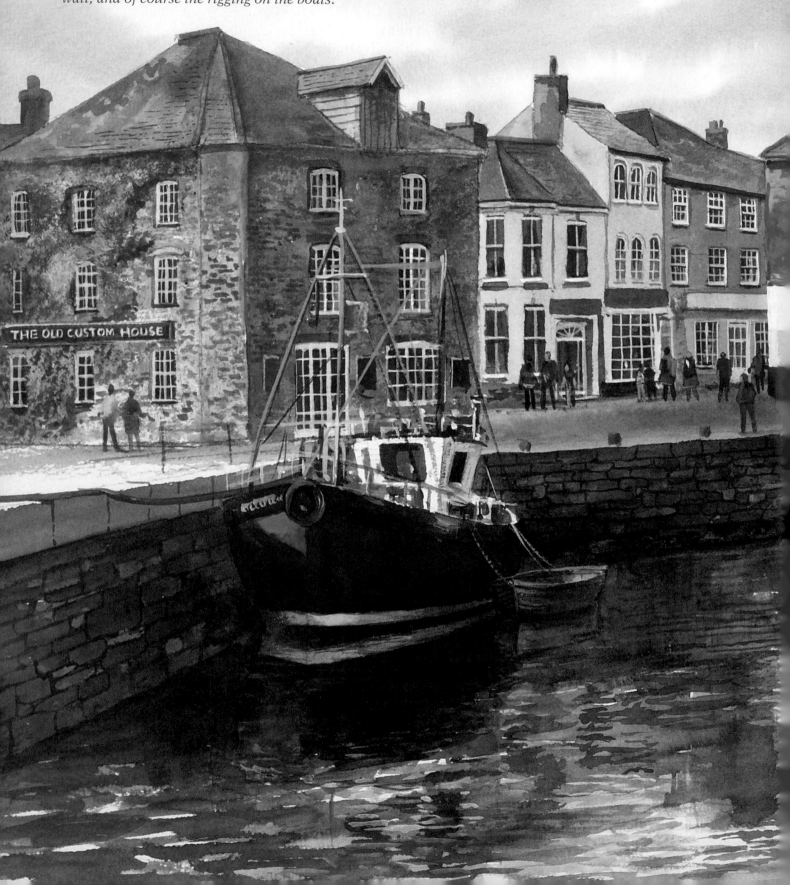

CHOOSING YOUR EQUIPMENT

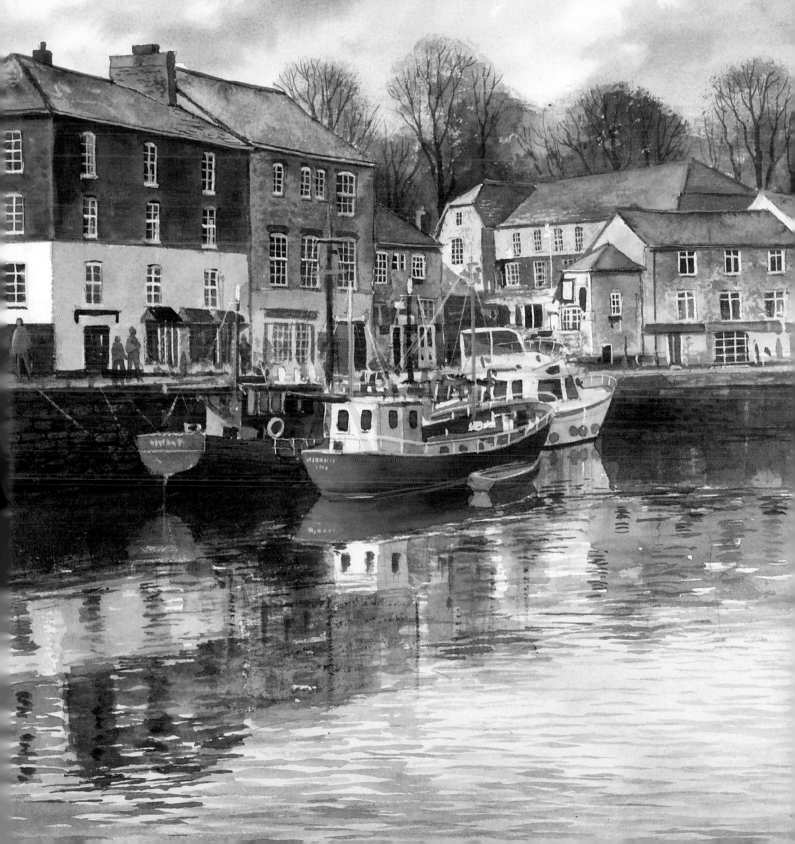

Brushes

Many years of experience have taught me what to look for in the ideal brush, and most artists adapt or customise standard brushes to suit their particular needs. I have gone one step further and developed a range of brushes, ready-customised to do the job perfectly. The brushes featured in this book are part of that range, and will help you to achieve the best effects with the minimum of effort.

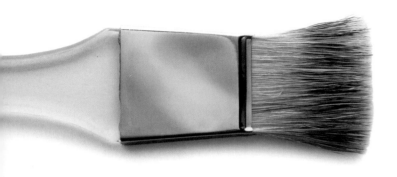

Golden leaf

This 2.5cm (1in) brush will hold a great deal of paint – or water. It is ideal for laying down washes for skies and water, because you do not need to reload too often. It can also be used with stippling and flicking techniques to paint trees, bushes and foreground leaves. The brush is made from bristle blended with fine, natural hair. When the hair is wet it curls and keeps the bristles separate, so it is ideal for painting texture.

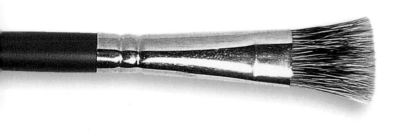

Foliage

A smaller version of the golden leaf, this brush is designed to produce foliage and texture with the minimum of effort: just stipple the brush over the surface of the paper. It is ideal for painting trees, bushes and hedgerows as well as texture on buildings, footpaths, walls and roads.

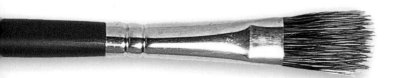

Wizard

This brush is made from a blend of natural hair, twenty per cent of which is slightly longer than the rest. The paint is held by the body of the brush and released through the longer hair, which forms small points. The effect of fine lines produced is ideal for grasses, hair and fur. It is also good for blending water and reflections.

Fan stippler

This brush is ideal for painting all kinds of trees, but instead of brush strokes, it is usually used to stipple. The blend of hair and bristle helps to create a range of different textural effects which are ideal for mimicking nature, including a realistic leaf effect.

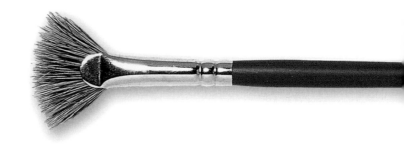

Fan gogh

This brush is made from a blend of natural hair and is thicker than many other fan brushes. This means that it holds plenty of paint and does not separate. It can be used for a wide range of trees including cypresses, firs, willows and palms; for grasses and reeds; for textures like fur, and even for reflections on water.

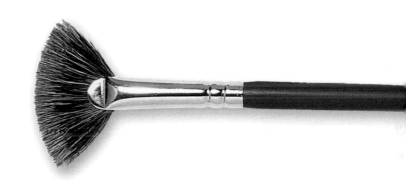

Stippler px

Using the same hair combination as the foliage and fan stippler brushes, this brush is used, as the name suggests, for stippling and creating foliage and texture for trees and bushes. The px refers to the clear plastic handle with a cut-away end, which is used for scraping out elements such as grasses, tree trunks and stones.

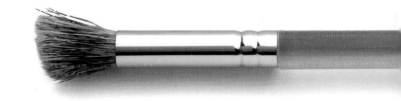

Sword

This traditional brush was originally used in signwriting and coachwork. It has become very popular with watercolourists because it is ideal for creating grasses and rushes. It can also be used for floral painting.

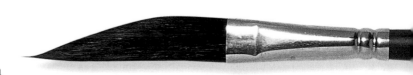

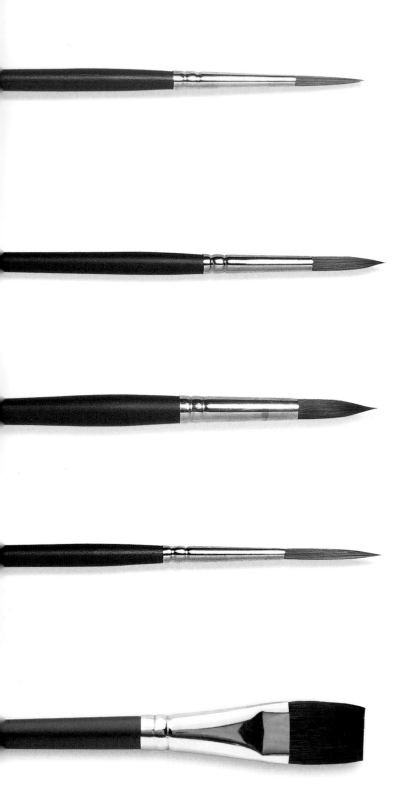

Small detail

Detail brushes, as you might imagine, are usually used when painting detail! This type of brush is also known as a round, and I find that three sizes – small, medium and large – give me plenty of scope. The small detail brush is best for refining and sharpening up sections of your painting and, of course, adding your signature to the finished picture.

Medium detail

The medium detail is the workhorse brush – it is the one you reach for before trying any of the other detail brushes. It will go to quite a fine point, and is suitable for adding all but the finest detail to a painting.

Large detail

The large detail brush is extremely versatile. It can be used to add a determined statement to a painting; it holds a lot of paint yet will still go to quite a fine point. It can also be used for washing in skies.

Half-rigger

This brush is shorter than an ordinary rigger, which makes it easier to control. It is made from synthetic material and is designed to keep its point and shape. It is useful for painting grasses and flowers and or course for painting the rigging on boats! Fully loaded, this brush will hold enough paint to complete a long, unbroken line.

Emperor 19mm (¾in) flat

This brush is made mostly from squirrel with a small amount of synthetic hair. The natural squirrel has excellent water holding capacity and the synthetic hair provides the spring and helps to control the shape.

Opposite
Shutter and Shade
The textures and foliage in this painting were created by stippling with the golden leaf brush and the flowers and window frame were masked with masking fluid. The dark shade next to the light and colourful flower bed adds contrast in tonal value, making the foreground appear brighter.

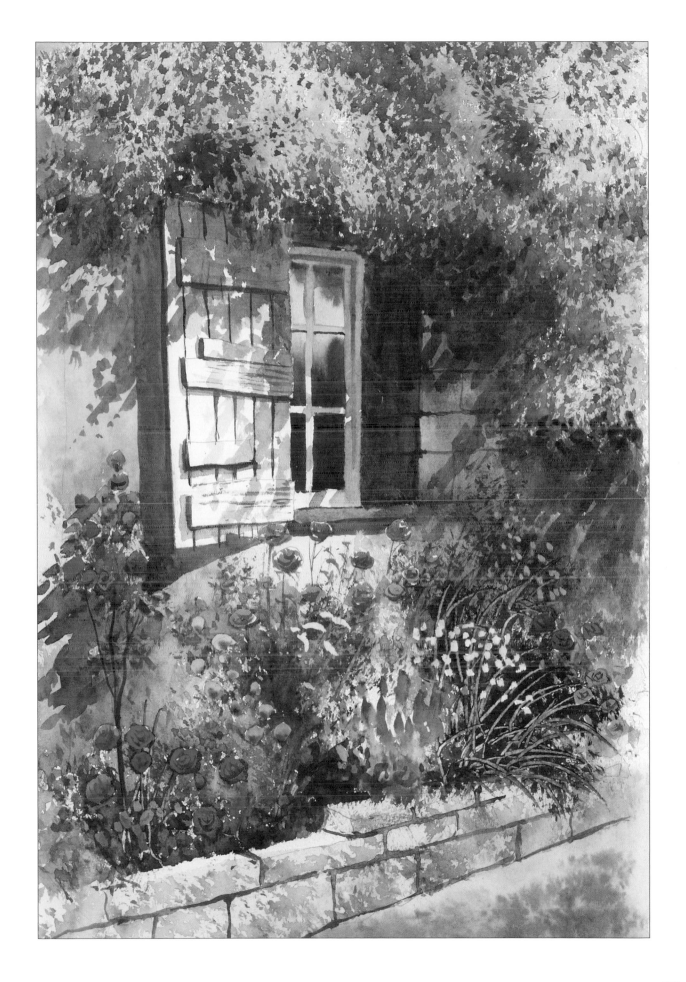

Materials

Watercolour paper

I have used Bockingford 300gsm (140lb) Rough throughout the book. It is a good quality, reliable paper, not too soft and not too absorbent and best suited for the techniques I use. The choice of paper does seem to depend on what paper you first learn to paint on, as other brands that you try later do not always give the same results.

Paints

I do not recommend any particular brand of paint, but you should start with artist's quality. Its better to have fewer, better quality paints than a larger choice of inferior paint.

Masking fluid and brush

I would be lost without masking fluid. The liquid latex rubber mask protects areas of the paper from paint so that you do not need to paint around them. I use a special nylon brush to apply masking fluid.

Soap

I use soap to prevent masking fluid sticking to my brushes. Wipe the wet brush over the soap, and this will form a barrier between the masking fluid and the brush hair, preventing it from sticking. After use, the brush can then easily be rinsed out in water.

Eraser

We all make mistakes, so treat yourself to an eraser. I prefer a hard eraser rather than a soft putty eraser as they can smudge the paper.

Propelling pencil

I use a 5mm (¼in) 2B propelling pencil. It gives me a line of constant thickness with no need to sharpen it.

Ruling pen

Ideal for drawing fine lines and grasses, either with masking fluid or with watercolour paint.

Paper mask

A piece of scrap paper can be used to mask areas in your painting especially when stippling.

Hairdryer

You don't have to have a hairdryer to paint – you just need to have patience and to like watching paint dry. I prefer to speed up the process and use a hairdryer to dry my work.

Masking tape

You can use masking tape to create a neat border around your painting, and just to tape your paper to a board.

Kitchen paper

This can be used for mopping up excess water or paint from a painting, also it is useful for removing excess paint from an overloaded brush.

Bucket

I disapprove of small jam jars for water pots; they simply are not big enough to do the job. After only a few washes, you will be painting with dirty water. Using a bucket, on the other hand, means you can rinse out your brushes properly and the water remains cleaner for longer.

Clockwise from the top: kitchen paper, hairdryer, watercolour paper, scrap paper, paints, a masking fluid brush, propelling pencil and ruling pen, masking fluid, soap, eraser and masking tape.

My palette

I am not a great fan of a limited palette, by which I mean that I cannot see the point of struggling with two or three colours when there are so many to choose from. My style of painting is based on a selection of colours that I think is balanced and varied.

Mixing greens is not easy. If it is that simple, why do so many artists struggle to create a green that does not look muddy? To make things easy for you and myself, I have developed my own natural-looking greens, a fresh, light green, a medium-toned green and a cool dark green.

Another special colour I use is shadow, which is a subtle purple hue, ideal, as its name suggests, for painting shadows. It can be washed over a background, and since it is translucent, the background colour will show through.

The last colour on my list is white gouache. Purists might frown at the use of white, but who are you trying to please – yourself or others? I believe Constable and Turner used it with their watercolours, and if it was good enough for them, it is good enough for me.

The colours I use

Cadmium yellow

Raw sienna

Burnt sienna

Burnt umber

Cadmium red

Permanent rose

Magenta

Cobalt blue

Ultramarine

Turquoise

Sunlit green

Country olive

Midnight green

Shadow

Opposite

Blaze of Bougainvillea

This striking study of a window and doorway is dominated by the bright, colourful bougainvillea. For this I used a mixture of magenta and permanent rose with the golden leaf brush. The sunlit blue shutters really stand out against the vibrant background, and dark shadows across the foot of the painting help to contrast and highlight the sunshine on the wall and shutters. Texture on the stonework was created by stippling using the foliage brush.

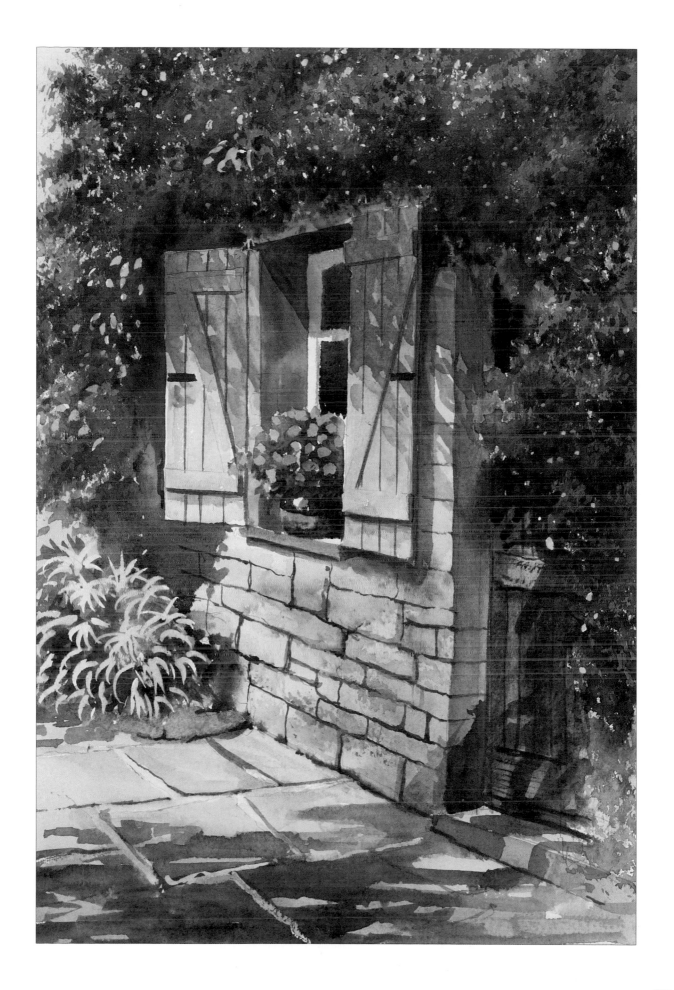

Colour mixing

Having fourteen or more colours in a palette gives you plenty of scope when you are trying to mix the right colour. Here are a few colour mixes that might help.

Mixing greys

To mix a really dark colour such as black, I use ultramarine and burnt umber. A lighter grey is achieved simply by adding more water and diluting the colour. If you mix a blue and a brown, you will get a grey. Try cobalt blue and burnt sienna: for a warm grey add more brown, and for a cooler grey, add more blue.

Burnt umber and ultramarine

Burnt sienna and cobalt blue

Adding colours to greens

Adding other colours to ready-mixed greens can really extend your colour range; here are some suggestions.

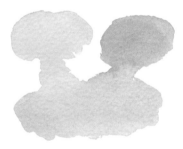

Sunlit green with cobalt blue
A pale misty green for distant trees and woodlands.

Country olive and burnt umber
A warm, rich green for foreground trees and tree trunks.

Midnight green and ultramarine
A dark bluey-green, ideal for seascapes and shade on trees.

Painting brickwork

A good mix for this is: raw sienna, burnt sienna and cobalt blue. Adding the blue helps to tone down the browns.

Raw sienna, burnt sienna and cobalt blue

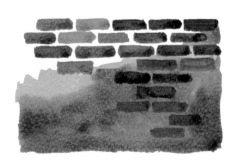

Painting the sea
When painting seascapes, I use a variety of blues and greens, but my favourite shade is midnight green and ultramarine.

Painting clouds
To create the shadow on clouds, I use ultramarine and burnt umber. This grey should be slightly more blue than brown.

Overleaf

Lynmouth, North Devon
My outstanding memory of this North Devon holiday hot spot was the mass of brightly coloured blooms, but my photographs did not do them justice, so in my painting I simply added more flowers to create a kaleidoscope of colour. The trees were painted with the golden leaf after the roofs were masked with a piece of paper. The wizard is a good choice of brush to paint thatched roofs. Adding people to the painting can inject some interest, although maybe not too many as this might spoil the tranquillity of the scene and distract from the flowers.

USING THE
BRUSHES

Golden leaf

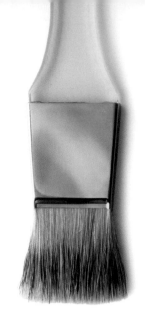

This unique brush holds lots of water and is ideal for laying washes and painting skies. It is also perfect for reproducing texture and foliage, as its name suggests. Care must be taken not to overload this brush when stippling, as too much liquid will result in the texture flooding together and becoming a flat wash. To overcome this, remove the excess water by squeezing the brush between your fingers, or dab the wet brush on to some absorbent kitchen paper.

Painting a tree

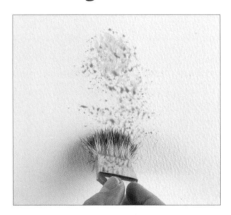

1. Stipple on the lighter parts of the foliage using sunlit green.

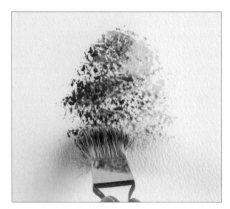

2. While the first green is still wet, change to country olive and stipple on the darker, shaded parts of the foliage.

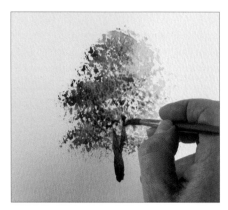

3. Mix country olive with burnt umber and use the medium detail brush to paint the tree trunk.

4. Use country olive and the golden leaf brush to flick up grasses under the tree.

The finished tree.

Opposite
Sunlit Garden
This colourful scene was painted mostly using the golden leaf brush. The background foliage was washed in first using a lighter colour, then once this was dry, a darker colour was stippled over it for the foliage detail. Masking fluid was used for the steps and flower heads.

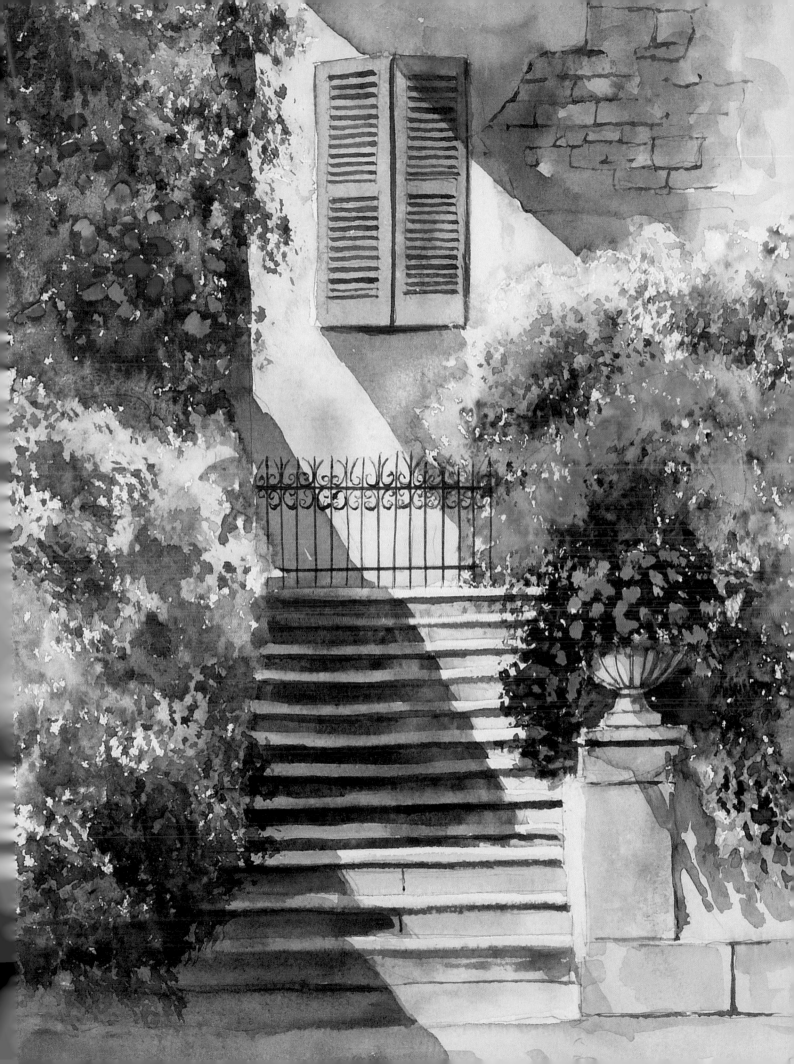

Foliage

The foliage brush is a smaller version of the golden leaf brush, and is basically for painting texture, so it is ideal for painting foliage and bushes. It can also be used to create texture on buildings and shingle beaches. For best results, do not overload the brush with too much paint, as this will flood the surface and the texture will be lost.

A bluebell wood

1. Wet the background first with clean water, then stipple on cobalt blue.

2. While the first colour is still wet, stipple on cadmium yellow around the blue. The colours will merge slightly.

3. Mix cadmium yellow with cobalt blue and stipple the resulting green over the other background colours, while they are wet.

4. Mix cobalt blue and permanent rose for the bluebell colour, and stipple this over the dry foreground area, leaving a space for a path in the middle. Allow to dry.

5. Paint the tree trunks with the half-rigger and a mix of cobalt blue and cadmium yellow.

6. Paint raw sienna on the path and allow to dry.

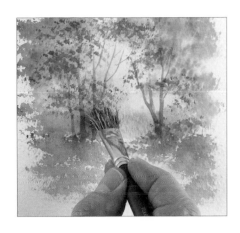

7. Stipple over the top of the dried foliage with a mix of country olive and cobalt blue.

8. Make a darker mix of the bluebell colours, cobalt blue and permanent rose, and stipple this over the dried foreground.

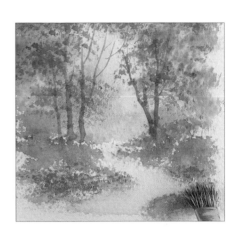

The finished painting.

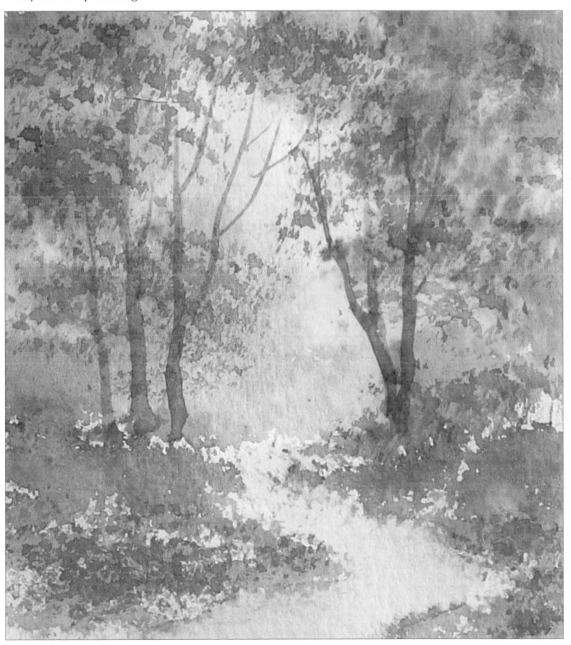

Trees in a landscape

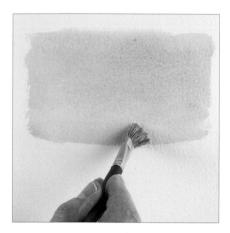

1. Paint on a pale sky wash of cobalt blue. Allow to dry.

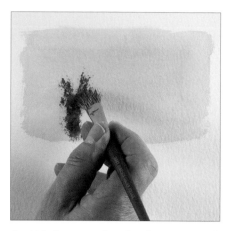

2. Pick up a fairly dry mix of midnight green and stipple the ivy on the tree.

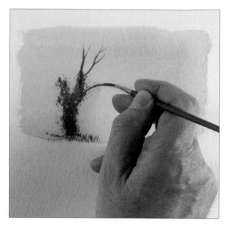

3. Use the same colour to paint the branches coming out of the ivy, with the half-rigger.

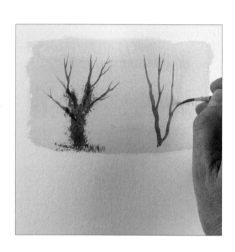

4. Paint the second tree, without ivy this time, using the half-rigger to create the trunk and branches.

5. Change back to the foliage brush and stipple the lighter foliage on the trees with sunlit green.

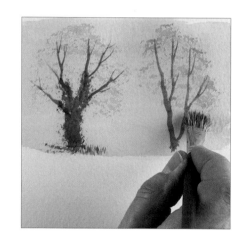

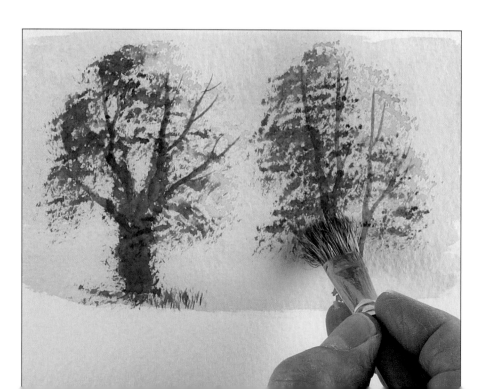

6. Change to country olive to stipple on the shaded parts of both trees.

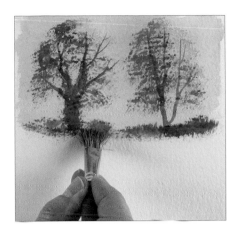

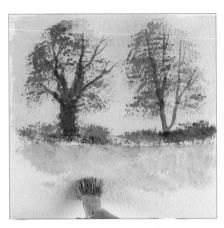

7. Paint the hedgerow beneath the trees with country olive and a combination of stippling and a flicking up motion.

8. Paint the cornfield in the foreground with raw sienna, stippling on texture.

9. Flick up grasses in the foreground with burnt sienna.

10. Pick up cadmium red on the tips of the bristles and stipple on poppies in the cornfield.

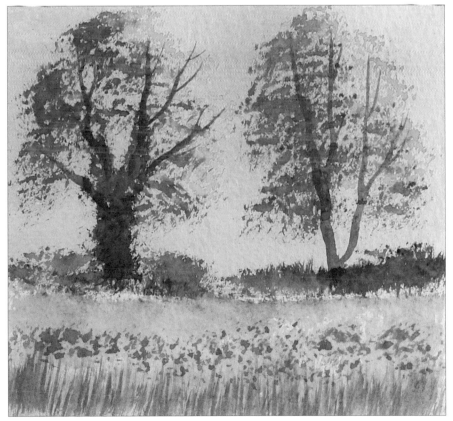

The finished painting.

Doorway

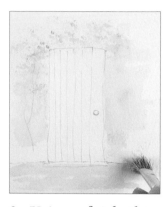

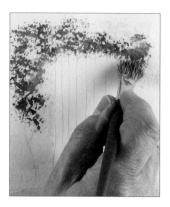

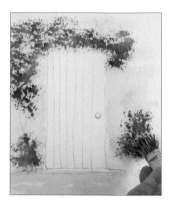

1. Paint a pale wash of burnt sienna over the foreground, and a raw sienna wash on the walls on either side of the door. Allow to dry.

2. Using a fairly thin mix of sunlit green, stipple foliage over the top of the door and at the bottom.

3. Mix midnight green and country olive and stipple darker foliage on the underside of the vine.

4. Stipple on flowers on the right-hand side of the door using permanent rose.

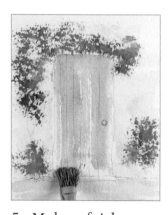

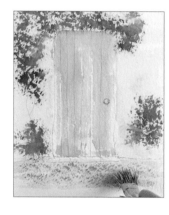

6. Stipple texture on to the ground with burnt sienna.

7. Use the half-rigger with a mix of ultramarine and burnt umber to paint the details of the door and the vine stem.

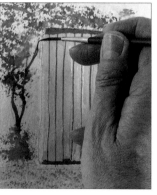

5. Make a fairly thin mix of cobalt blue and stroke this down the door, leaving it streaky with white showing, to suggest weathered paintwork.

The finished doorway. I added cadmium red flowers in the vine using the small detail brush.

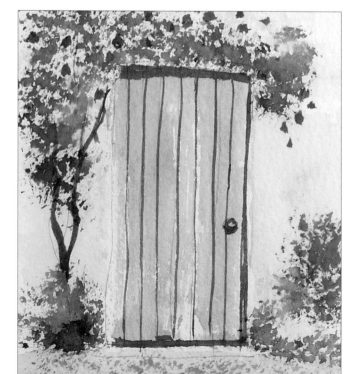

Safe Haven
This sleepy little harbour of Craster on the north-east coast of England is a fantastic location to paint. The texture on the buildings and beach was achieved by stippling with the foliage brush on to the dry background colour. Masking fluid was used on the large stones in the foreground and details on the boats and window frames were painted using the half-rigger.

Wizard

The wizard can be used to create a variety of effects which are good for painting grass, trees, feathers, fur, hair, thatched roofs and woodgrain. Load the brush with paint, hold it upright and just lightly touch the tip on to the paper. Draw it over the surface and the paint will flow through the tips of the hairs and produce a fine, streaked effect. If the body of the brush is in contact with the paper, more paint leaves the brush to produce a solid brush stroke.

Woodgrain

1. Paint a pale wash of burnt umber, using uneven brush strokes and leaving some white showing. Allow to dry.

2. Use the half-rigger to paint a knot in the wood with a darker mix of burnt umber.

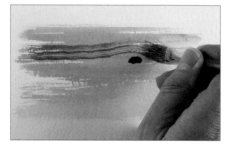

3. Pick up a dark mix of ultramarine and burnt umber on the wizard brush, and paint a streaky, uneven brush stroke around the knot.

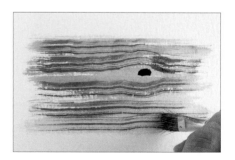

4. Continue painting the woodgrain below the knot as shown.

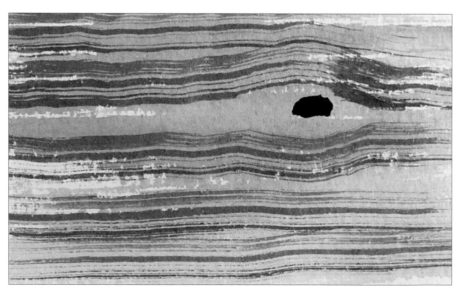

The finished woodgrain.

Silver birch trunks

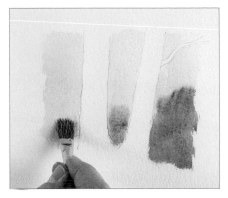

1. Draw the trunks and paint the background around them with a pale mix of sunlit green and country olive. While this is wet, drop in country olive lower down.

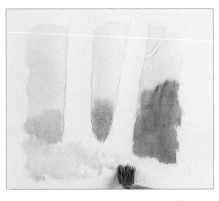

2. Paint sunlit green in the foreground and allow to dry.

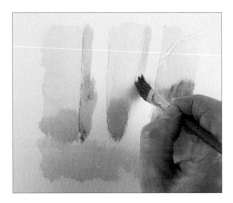

3. Mix cobalt blue with a touch of burnt umber to make a grey/blue, and shade the sides of the trees. Allow to dry.

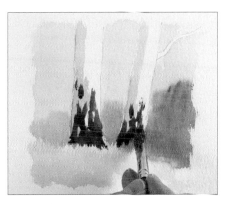

4. Make a very dark mix of cobalt blue and burnt umber, and use the side of the brush to dab on vertical strokes at the bottom of the trunks.

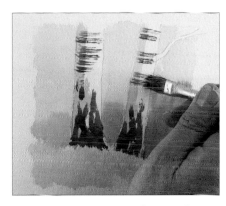

5. Paint horizontal streaks across the trunks to suggest the rings round the silver birch trunks.

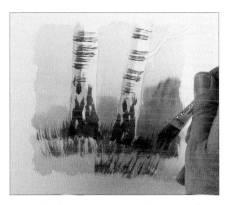

6. Flick up grasses beneath the trees using country olive.

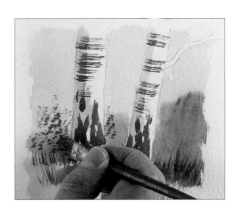

7. Pick up permanent rose on the tips of the bristles and stipple on flowers in the background.

The finished silver birches.

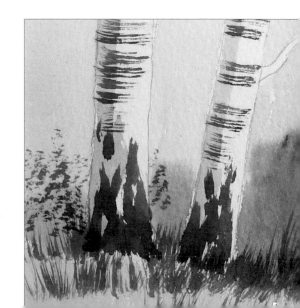

A wet into wet tree

 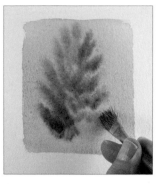 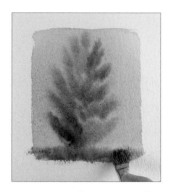

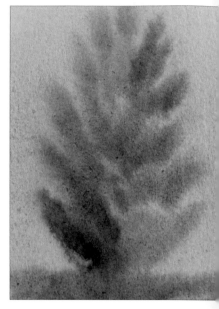

1. Paint a wash of cobalt blue, and while this is wet, paint on a fir tree shape with midnight green.

2. Continue using the wizard to paint in fir branches wet into wet.

3. Paint the ground with the same midnight green.

The finished tree. The wet into wet technique creates a misty, soft-edged image.

A wet on dry tree

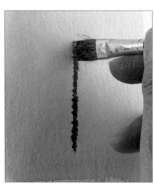 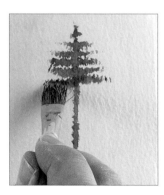 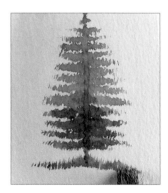

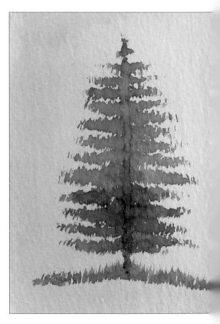

1. Paint the background in cobalt blue and allow it to dry. Use the flat tip of the brush to paint a tree trunk with midnight green.

2. Dab on horizontal brush strokes with midnight green to paint the branches.

3. Paint short, dabbing brush strokes in the same colour to suggest grass under the tree.

The finished tree. Note how the image is much crisper when you use this technique.

A dog's fur

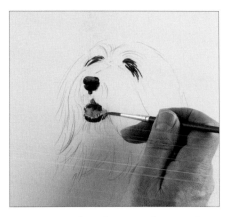 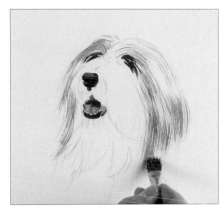 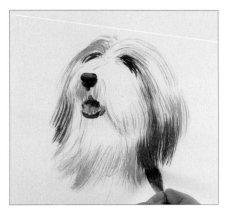

1. Draw the dog and use the small detail brush to paint the eyes, nose and mouth with ultramarine and burnt umber. Allow to dry, then paint the tongue with a pale wash of cadmium red.

2. Make a mid-tone grey wash from burnt umber and ultramarine, the consistency of semi-skimmed milk, and paint sweeping strokes to create the dog's fur.

3. Next, mix a darker grey and paint the shaded parts of the dog's fur.

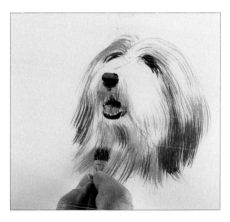

4. Mix a warm grey-brown from burnt umber with a touch of ultramarine and paint around the dog's snout and under its chin.

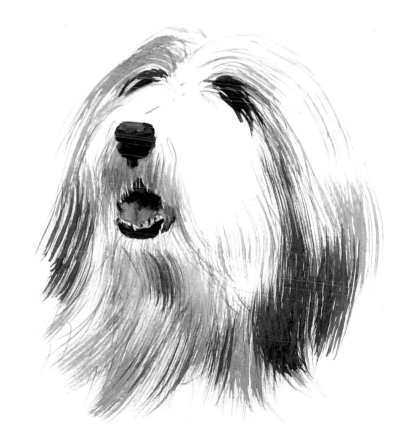

The finished dog.

Fan stippler

As the name suggests, the fan stippler is a fan-shaped brush for stippling. By stippling and dabbing with the brush, texture is created by the unique hair mix. Lightly stippling produces a fine texture, but don't have the brush too wet, as if the brush is overloaded with too much paint, the paint floods out and the texture joins together like a wash. To overcome this, simply dab the brush on to some kitchen paper to remove some of the paint. A more dense texture can be created by firmly stippling and pushing the brush into the paper.

Autumn tree

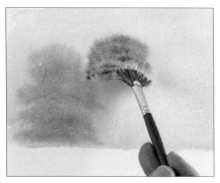

1. Paint the background in cobalt blue, then use the rounded end of the brush to dab on tree shapes wet into wet with a mix of burnt umber and cobalt blue.

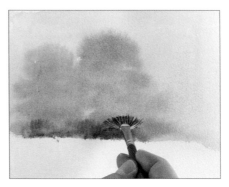

2. Still working wet into wet, stipple a darker mix of the same colours at the bottom of the tree shapes.

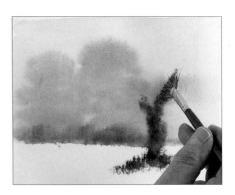

3. Use the tips of the bristles in an upright position to stipple on ivy with ultramarine and midnight green.

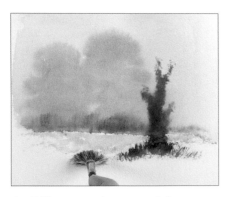

4. Mix raw sienna with a little cobalt blue and stipple the field in the background.

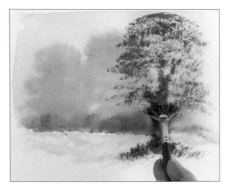

5. Stipple on the foliage with a mix of ultramarine and burnt umber.

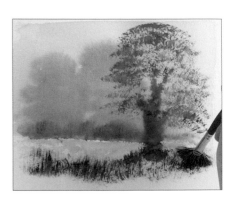

6. Flick up grasses in the foreground with a browner mix of the same colours.

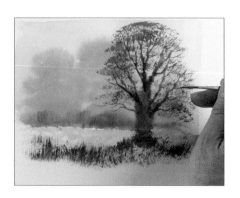

7. Paint branches with the half-rigger and the same mix of ultramarine and burnt umber.

The finished painting.

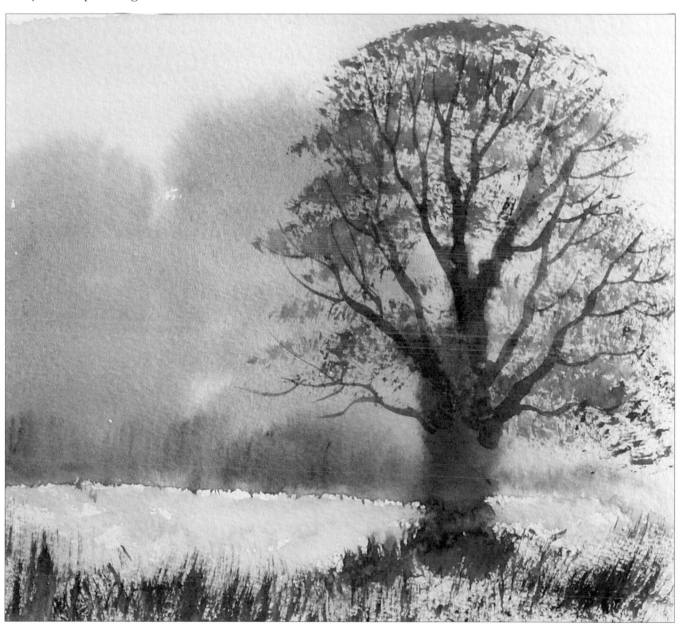

Summer tree

1. Paint the background with cobalt blue, and while this is wet, stipple on trees with midnight green and ultramarine.

2. Still working wet into wet, stipple on a darker, stronger mix of the same colours for the shaded parts of the trees. Allow to dry.

3. Working wet on dry, stipple on the ivy on the foreground tree and flick up grasses with midnight green.

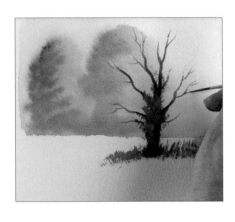

4. Paint branches using the half-rigger and midnight green.

5. Change back to the fan stippler and stipple on the lighter foliage with sunlit green.

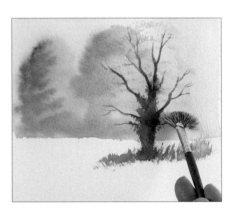

6. Stipple on darker foliage with a mix of midnight green and country olive.

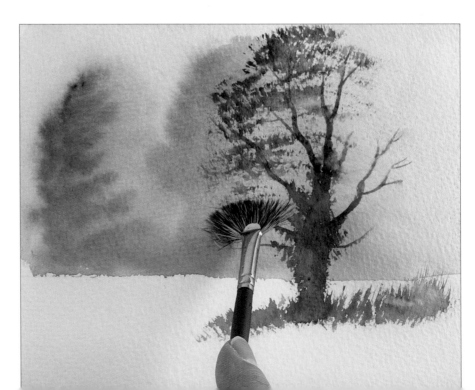

7. Paint the background field with a wash of raw sienna.

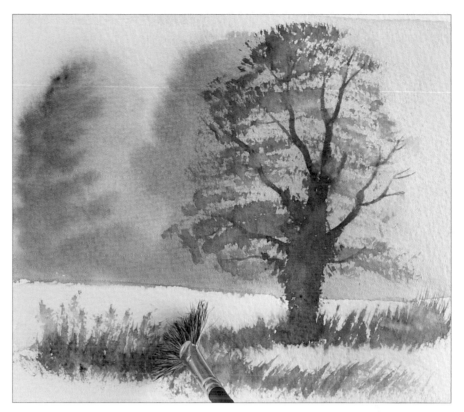

8. Flick up grasses with country olive, and turn the brush on its side and use the shape of the bristle tips to dab on grass heads.

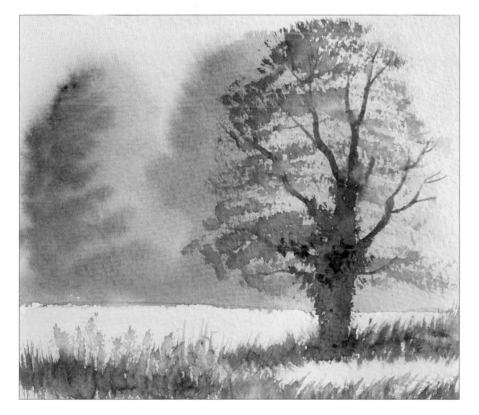

The finished summer tree.

Overleaf

Springtime in the Valley

The fan stippler is great for painting trees because of its rounded shape, but can also be used for painting other foliage and grasses. Starting with the pale blue/greens of the distant trees, I allowed these colours to mix together and create a misty background. The middle distance trees were painted a little darker, with less blue, and the foliage for the trees in the front was stippled on, leaving plenty of sky, then the tree trunks and branches were put in.

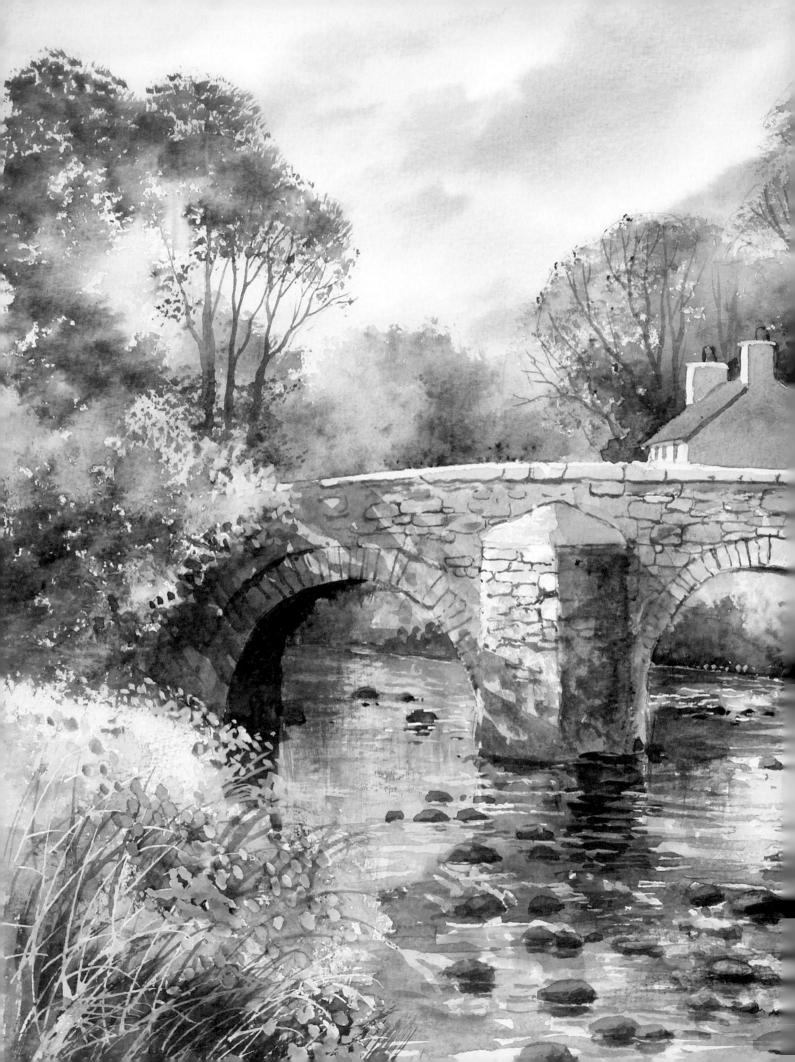

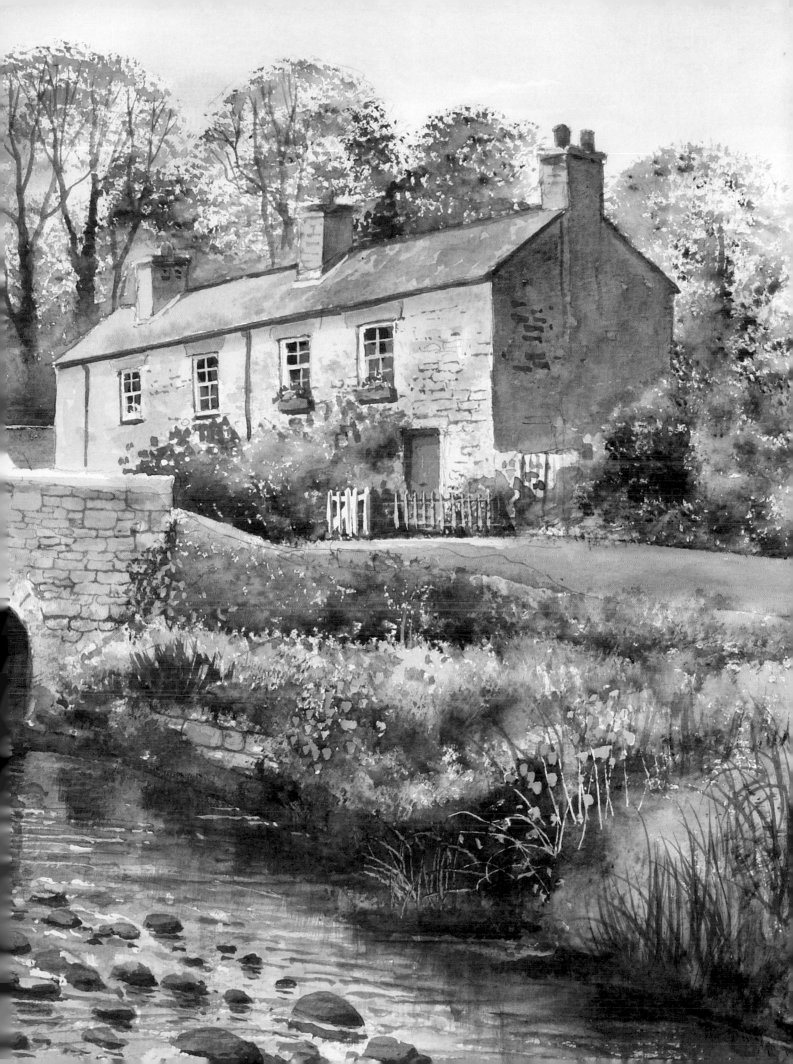

Fan gogh

Unlike many fan brushes, the fan gogh has a thick head of hair, so when the brush is wet, the hairs don't separate like thinner fan brushes. The fan gogh can be used to create many special effects. It is ideally shaped to paint trees and cloud formations, as well as grass and water.

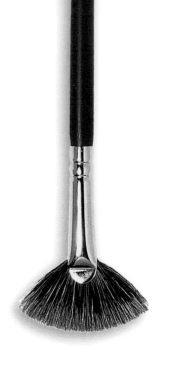

Loading the brush

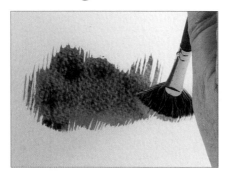

1. If you overload the fan gogh brush with paint, you will not get a streaked effect, as the extra paint will fill in the gaps.

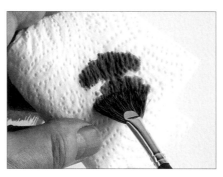

2. To avoid this, wipe the brush on a piece of kitchen paper to remove the excess paint.

3. Now the brush will create a streaked effect that is ideal for grasses and other elements of the landscape.

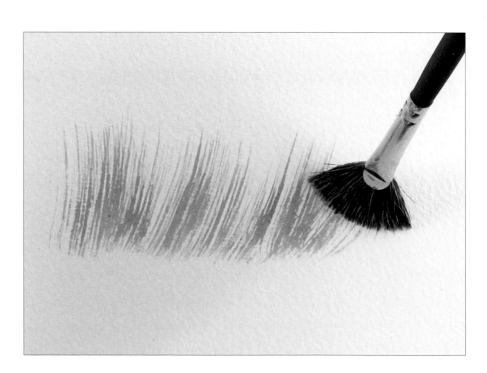

A wave

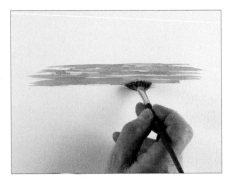 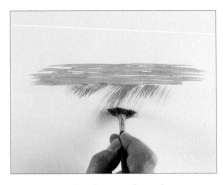 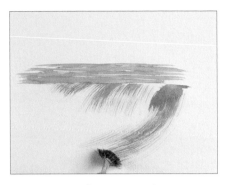

1. Make horizontal brush strokes with the tip of the brush and a wash of ultramarine.

2. Mix a little midnight green with the ultramarine and stroke the brush downwards to create the shape of the wave.

3. Sweep down again to create the slightly darker area of the wave.

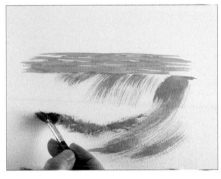 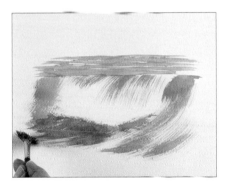 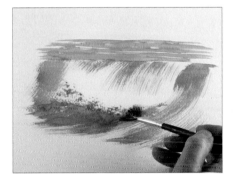

4. Stipple the underside of the wave's crest.

5. Make more dark, streaked brush strokes on the underside of the wave.

6. Use a slightly drier mix to stipple foam at the edge of the wave.

The finished wave.

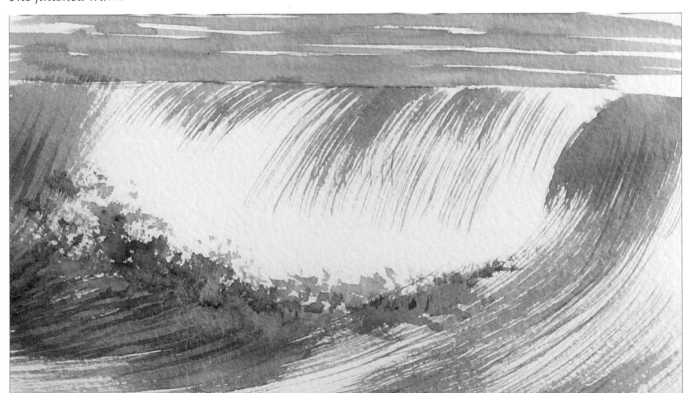

Waterfall

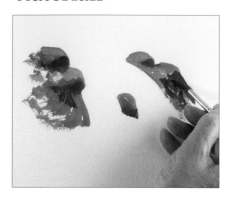

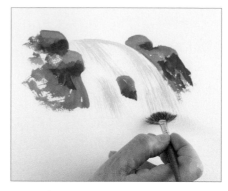

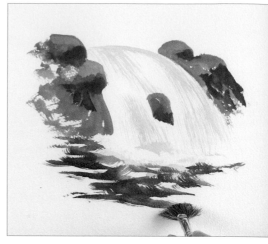

1. Paint the rocks with a mix of ultramarine and burnt umber and the medium detail brush. Vary the strength of the mix to paint lighter and shaded areas.

2. When the rocks are dry, change to the fan gogh brush and sweep ultramarine down the waterfall.

3. Mix midnight green with ultramarine and make horizontal marks, tipping the brush back and forth to create ripples.

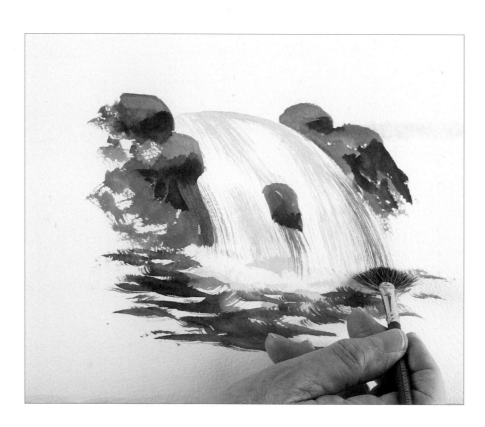

4. Stroke a little of the same mix down the waterfall.

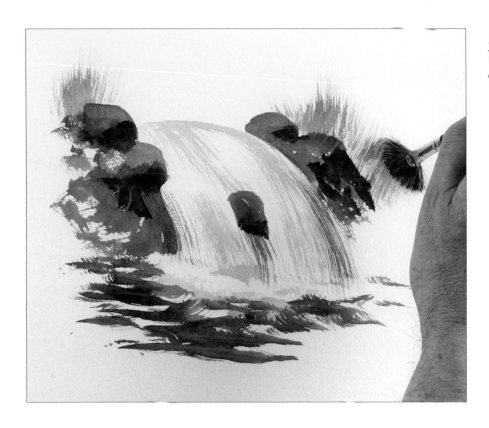

5. Flick up grasses beyond the rocks using country olive.

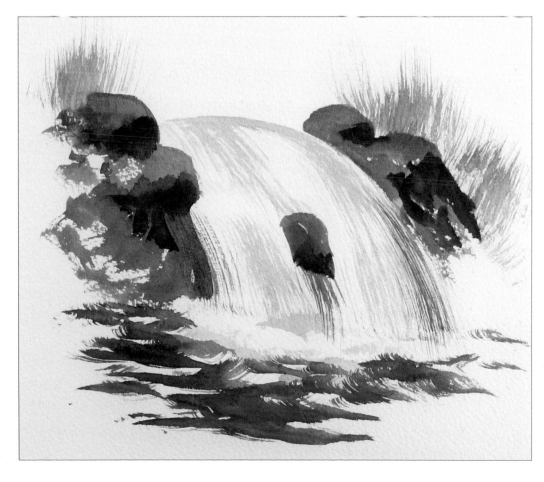

The finished waterfall.

43

Misty landscape with reflections

1. Wet the paper first and paint on ultramarine at the top and bottom.

2. Paint raw sienna in the middle.

3. Mix burnt umber and ultramarine and while the background is still wet, make horizontal marks across the scene for the waterline.

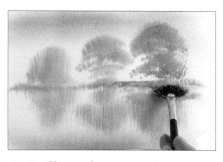

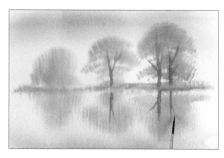

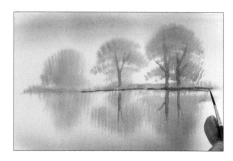

4. Still working wet into wet, use downward brush strokes to create tree shapes and their reflections below, with the same mix.

5. Use the half-rigger to paint trunks and branches with a slightly stronger mix of the same colours.

6. Darken the waterline in the same way.

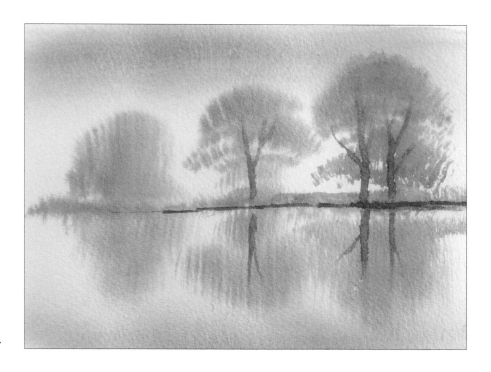

The finished landscape.

44

A cloudy sky

1. Wet the paper first. Start at the top, painting horizontal strokes of ultramarine back and forth, moving down the paper. The paint will be diluted lower down, making the sky paler.

2. While the sky is wet, paint in cloud shapes with a mix of ultramarine and burnt umber.

3. Wash the brush, squeeze it out and use it to lift out paint from the sunlit parts of the clouds.

The finished sky.

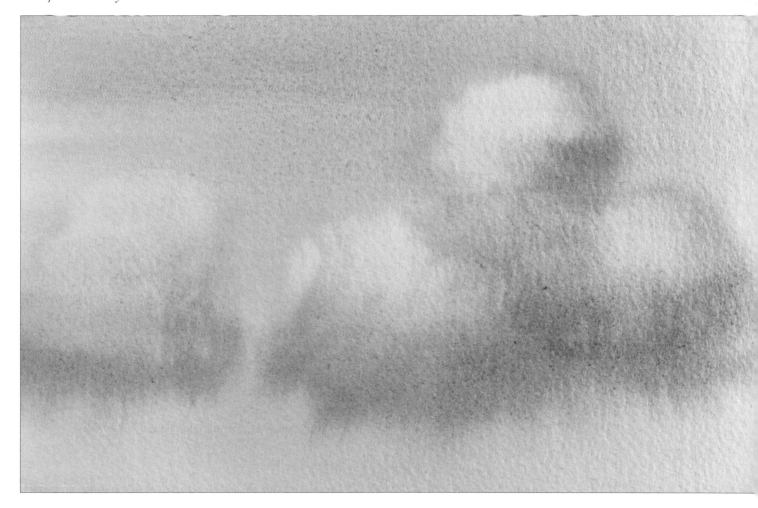

A summer sky

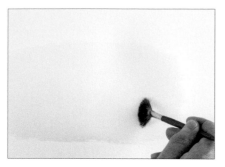 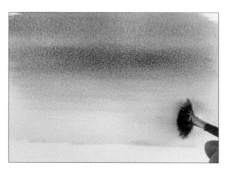 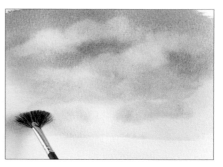

1. Wet the paper. Paint a pale wash of raw sienna at the bottom of the sky.

2. Paint a wash of ultramarine at the top of the sky, and drag it lightly down into the raw sienna.

3. Wash and squeeze out the brush and lift out cloud from the blue part of the sky. Keep washing it and squeezing it out. When it picks up colour, paint this on to the lower part of the sky to create smaller clouds.

The finished sky.

Opposite
Weeping Willow
The fan gogh is the perfect brush for painting the backdrop of trees in the idyllic riverside view of Bourton-on-the-Water, deep in the heart of the Cotswolds. Painting the weeping willow with the fan gogh was simple: I washed in the light green first by dragging the colour over and down, like a waterfall. Then, holding the brush upright and the head of the brush vertically, I used a dark green to stipple the cascading foliage. The water and reflections were then painted by lightly blending the colours with the fan gogh. I finished with some horizontal ripples created using the small detail brush.

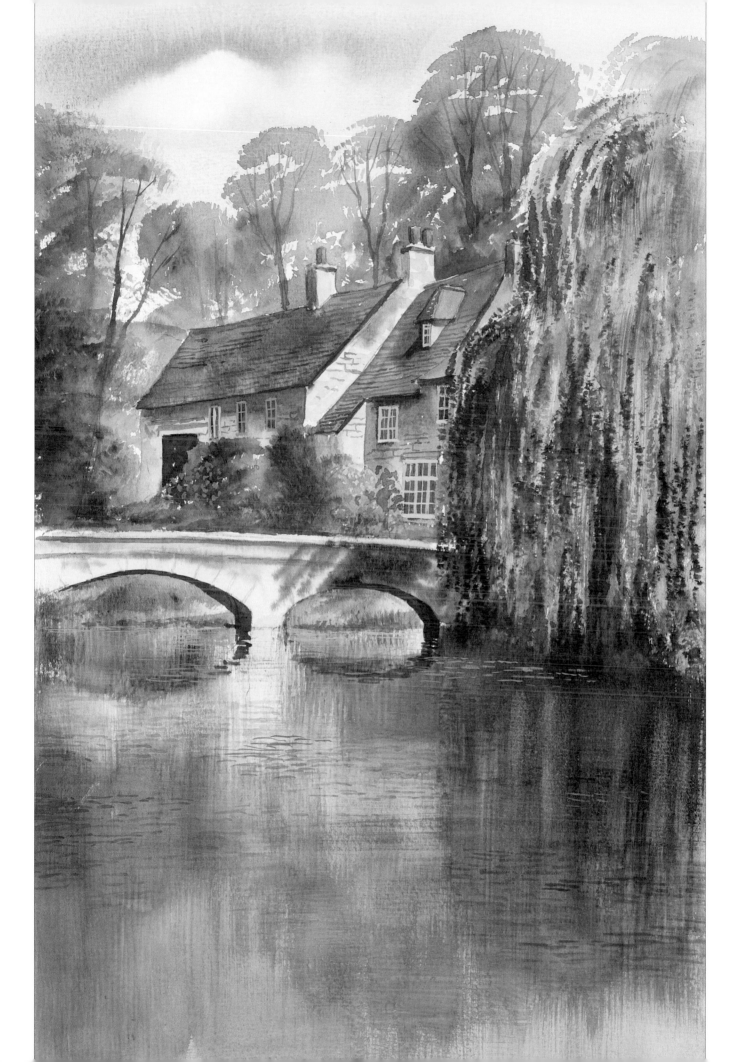

Stippler px

The stippler px is an ideal brush for painting trees and foliage. Simply load the brush with paint, then tap the brush on to the palette or other flat surface to open up and splay the brush hairs. Stipple by tapping the brush up and down on the paper. Do not overload the brush, as this will result in the texture filling in. The second great feature of this brush is the clear plastic handle with a sloping cut-away end which acts as a scraper – great for scraping out grasses and tree trunks.

A simple tree

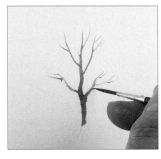

1. Paint the trunk and branches with the half-rigger and burnt umber mixed with country olive.

2. Stipple on the lighter parts of the foliage with sunlit green.

3. Stipple the shaded part of the foliage with country olive, and stipple and drag the same colour to create grass under the tree.

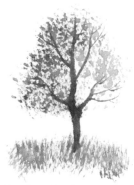

The finished tree.

Summer foliage

1. Stipple on sunlit green for the lighter foliage, then country olive for the darker parts of the foliage.

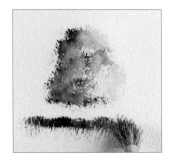

2. Paint the grass with country olive.

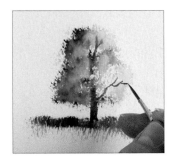

3. Use the half-rigger to paint a trunk and branches with country olive, leaving gaps for foliage.

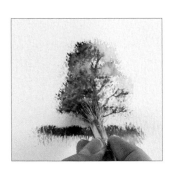

4. When dry, stipple on more country olive.

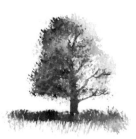

The finished tree.

Scraping out

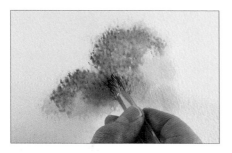

1. Stipple on raw sienna, then stipple burnt sienna on top, wet into wet.

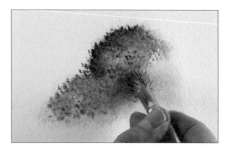

2. Stipple a little burnt umber round the edge of the tree shapes.

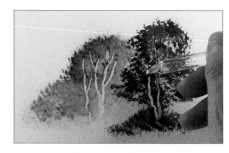

3. Stipple on a darker tree using burnt umber. While the paint is wet, use the specially shaped handle end of the stippler to scrape out trunks and branches.

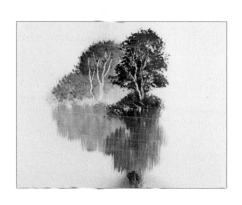

4. Mix raw sienna and burnt sienna and sweep down colour for reflections. Repeat with burnt umber for the reflection of the darker tree.

5. While the paint is wet, scrape out the reflections of the trunks and branches.

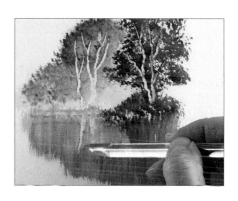

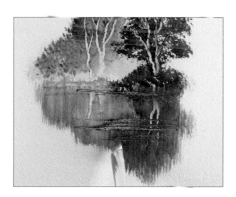

6. Scrape out horizontal marks in the reflections to suggest ripples.

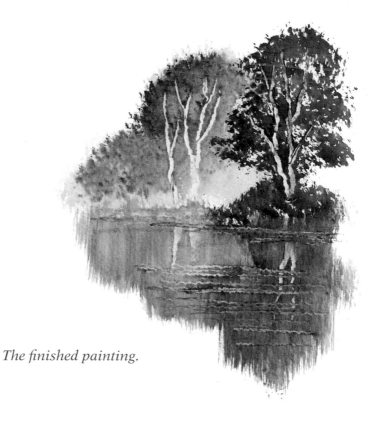

The finished painting.

A tree trunk

1. Paint the tree trunk with the large detail brush and a thick mix of country olive and burnt umber.

2. While the paint is wet, use the scraper end of the handle to scrape out short marks to suggest the texture of bark.

The finished tree trunk.

Scraped out grasses

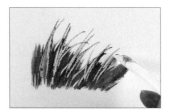

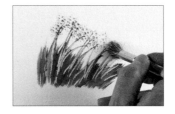

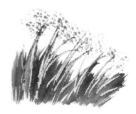

1. Paint grass with country olive.

2. Scrape out lighter grasses with the stippler handle.

3. Stipple on flowers using the brush end of the stippler and permanent rose.

The finished grasses.

Scraping out stones

1. Stipple on burnt umber, thickening the mix to create solid colour at the bottom of the wall.

2. While the paint is still wet, use the handle end of the brush to scrape out stones.

The finished effect.

Opposite
Woodland Stream
Almost this entire painting was created using the stippler px and scraping out. Care must be taken not to have the paint too wet when scraping out, as the paint will flood back into the groove. The only other brush used was the medium detail brush to paint some of the branches.

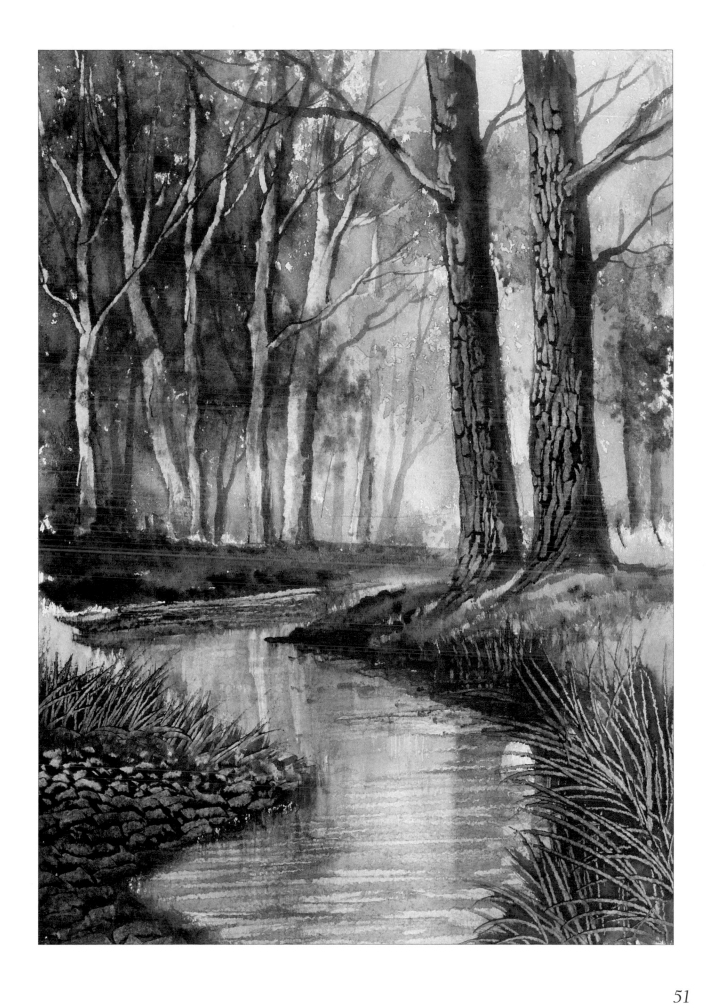

Sword

This unusual brush is good for painting grasses and riverside reeds. Hold the brush upright with the blade pointing away from you, then draw the brush over the paper and the paint will flow down the brush and through the blade edge to give you a very fine line. A tip is to fully load the whole of the brush, not just the end. This brush is also ideal for painting ripples on water and floral paintings.

Rippled water

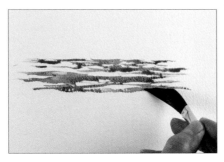

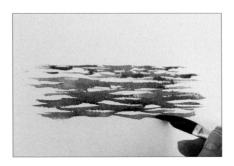

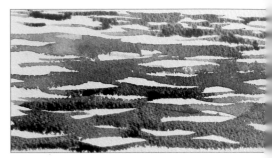

1. Use the point of the sword brush to paint short horizontal strokes to suggest rippled water.

2. Add midnight green to the mix and continue down the paper, painting larger, broader brush strokes.

The finished water. More ultramarine has been added to the mix in the foreground to darken the colour.

Rose

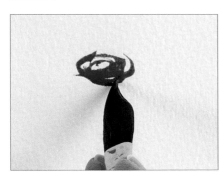

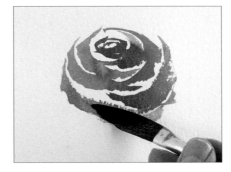

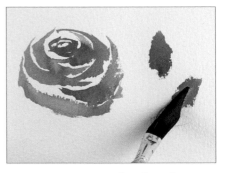

1. Paint the centre of the rose with cadmium red, making tight, circular brush strokes with the tip of the sword brush.

2. Continue painting the thicker outer petals of the rose, using the thicker part of the brush. Make sure the long, stright edge of the brush always points to the centre of the rose.

3. To paint rosebuds, place the brush on the paper and wiggle it from side to side.

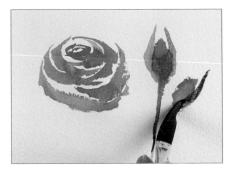

4. Pick up midnight green and, still with the long edge of the brush pointing towards the centre, push the brush on to the paper, cupping it round the bud and taking it down to create the stalk.

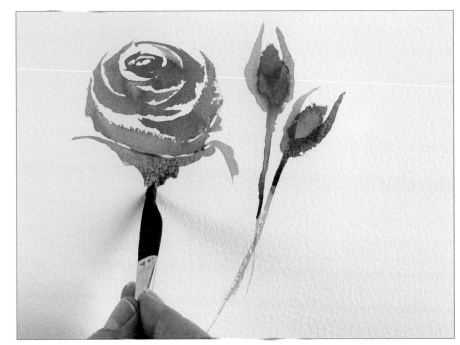

5. Add the leaves and stalk of the main rose in the same way.

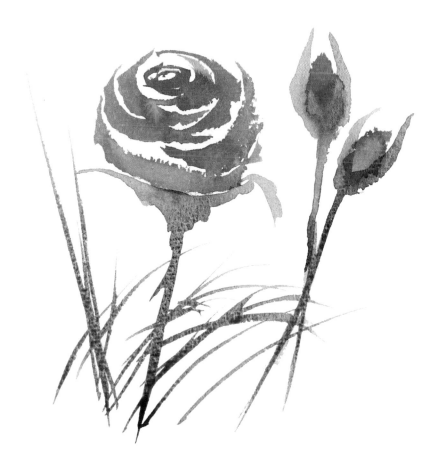

The finished rose.

Detail brushes

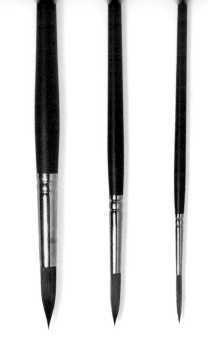

The first brush most artists buy is a traditional round brush and some artists will tell you that that is the only brush you need. Of course I don't subscribe to that view, but you do need round brushes that keep their points, and these brushes are for painting detail. When choosing which size brush to use, consider the area you are trying to cover. Don't fiddle with a small brush over a large area – just use a larger brush.

A weathered wall

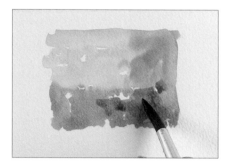

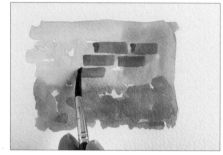

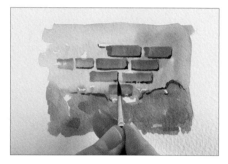

1. Use the large detail brush for the initial washes. Paint the background with a thin wash of raw sienna, then drop in burnt sienna while this is wet, allowing it to spread and merge unevenly. Allow to dry.

2. Change to the medium detail brush to paint brick shapes wet on dry. Pick up a mix of burnt sienna and burnt umber and paint each brick with one horizontal stroke. Allow to dry.

3. Use the small detail brush to paint the shadowed edges of the bricks with a dark mix of burnt umber and ultramarine.

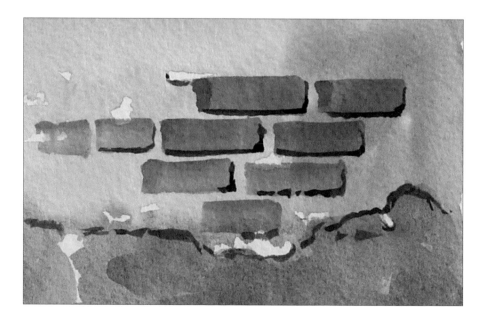

The finished wall.

54

A barn

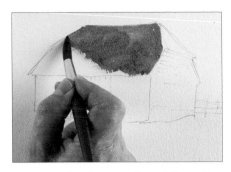

1. Use the large detail brush to paint the roof with burnt sienna. You should be able to paint a good edge with the point of the brush.

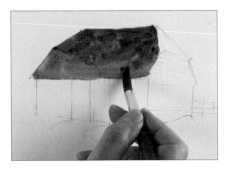

2. While the first colour is wet, drop in shadow colour.

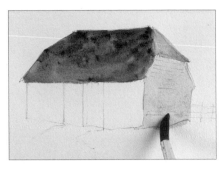

3. Paint the lit gable end of the roof with very pale burnt sienna and allow it to dry. Paint the lit wall of the barn with raw sienna and a touch of country olive, still using the large detail brush.

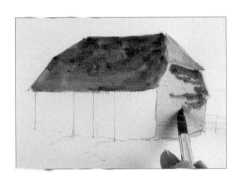

4. Add texture by dropping in a mix of country olive and ultramarine, allowing the green to spread into the wet background.

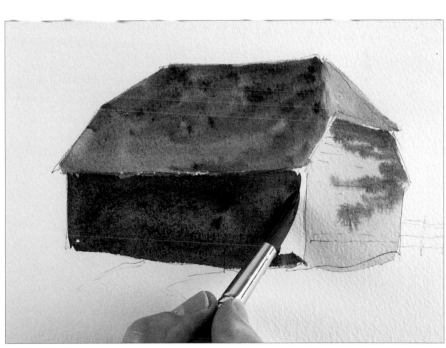

5. Paint the dark wall of the barn with country olive and burnt umber. Allow to dry.

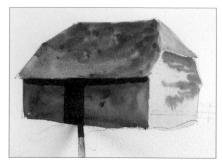

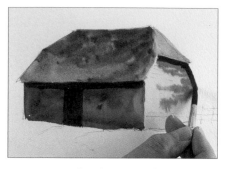

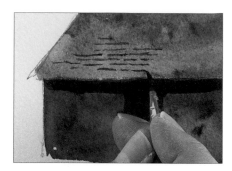

6. Change to the medium detail brush and paint a dark shadow under the eaves with ultramarine and burnt sienna. Paint the dark of the doorway in the same way.

7. Paint shadow under the eaves on the lit end of the barn.

8. Change to the small detail brush and use the same dark mix to suggest tiles on the roof with small horizontal marks. Do not make them too neat and even.

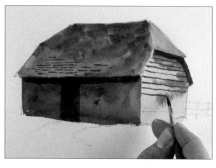

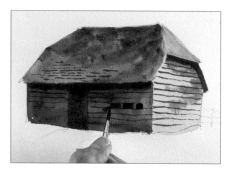

9. Paint the weatherboarding on the lit end of the barn in the same way.

10. Finally paint the weatherboarding on the shaded side of the barn, and add marks suggesting the dark showing through where the boards are broken.

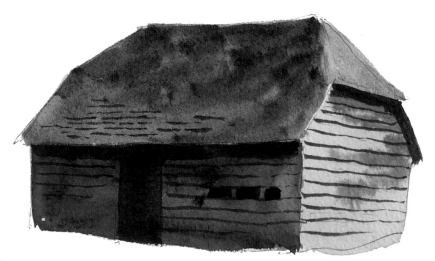

The finished barn.

Half-rigger

This brush is great for very fine detail such as branches and twigs when painting trees. Always make sure you load the half-rigger brush fully. This will allow you to paint long, continuous lines without taking your brush off the paper.

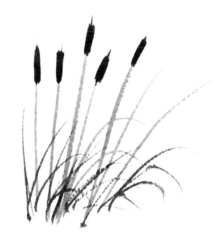

Bulrushes

1. Load the half-rigger brush fully with a pale wash of burnt umber. Hold the brush upright and sweep it upwards to create bulrushes.

2. Paint the bulrush heads with a much stronger mix of burnt umber.

The finished bulrushes.

Grasses

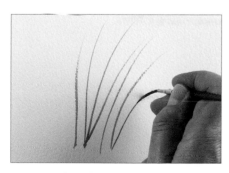 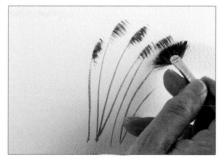

1. Stroke the brush upwards to create grasses with a thin wash of burnt umber.

2. Pick up burnt umber on a fairly dry fan gogh brush and paint the seed heads, using the shape of the brush and dragging it down.

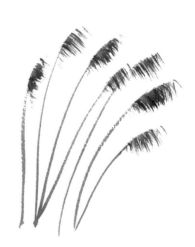

The finished grasses.

Adding detail

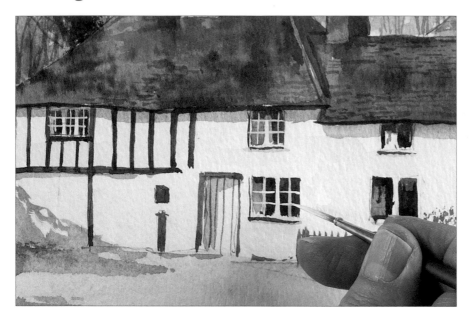

You can use the half-rigger with neat white gouache to add details like window frames to a finished painting, as shown here.

The finished painting. The half-rigger was also used to paint other details on the buildings, and the trees.

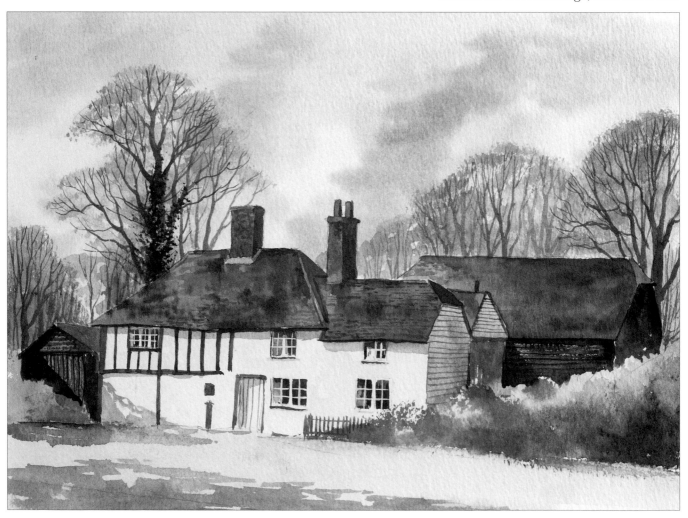

Emperor 19mm (¾in) flat

This brush has many uses such as painting water, reflections and ripples. It is ideal for tackling buildings and subjects with straight edges.

Lifting out

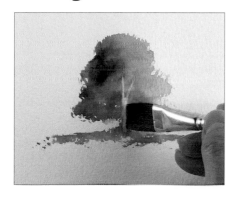

1. Paint a tree with the fan stippler and allow it to dry. Wet the 19mm (¾in) flat brush, dab it dry on kitchen paper and use the flat edge to lift out a trunk and branches.

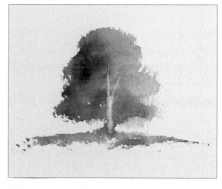

The finished tree.

Painting ripples

1. Pick up a wash of ultramarine and paint the most distant ripples by just placing the edge of the brush on the paper.

2. Add a tiny bit of midnight green to the mix and rock the brush in a shallow arc, creating slightly larger, greener ripples in the middle distance.

3. Make still larger, greener brush strokes for the foreground water.

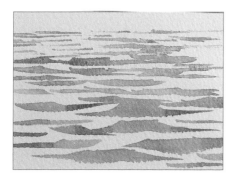

The finished water.

Overleaf
First Snow
Bourton-on-the-Water in the Cotswolds.

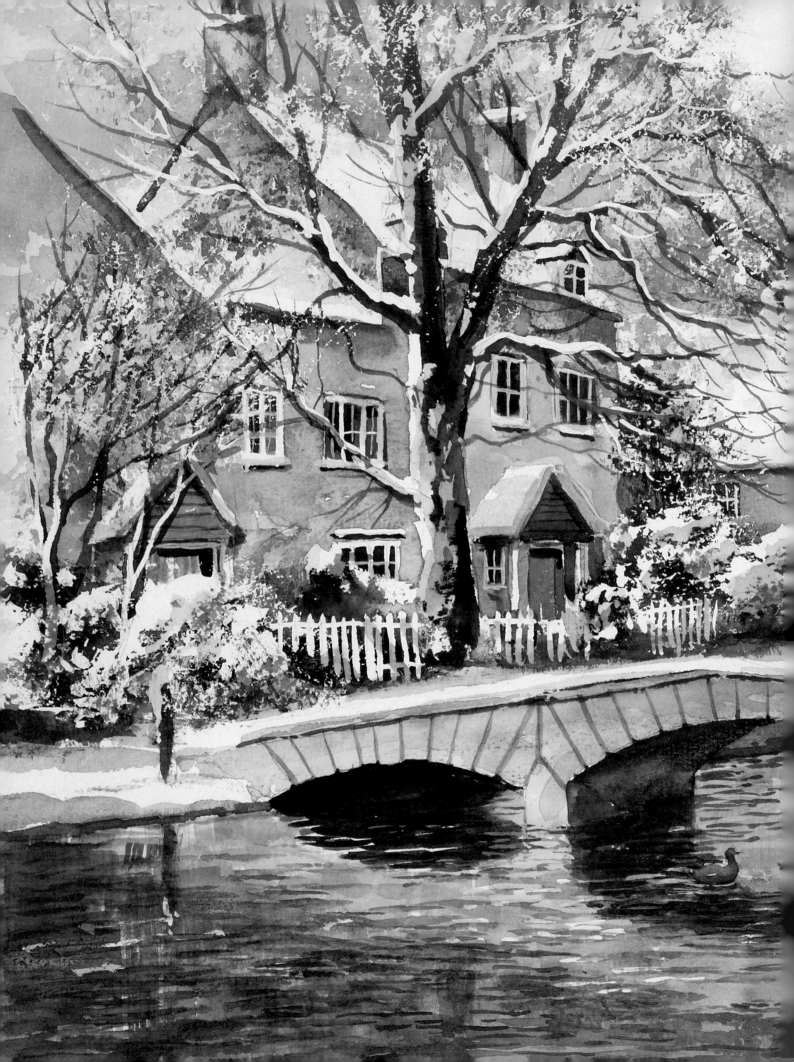

TECHNIQUES

Wet into wet

Wet into wet is the cornerstone of watercolour painting. When you place wet paint into a wet area, the paint flows and dissolves into the first wash, giving you a soft, misty edge. The two colours are allowed to mix on the paper. If the first colour is too dry, the second colour will have a hard edge, so timing is the secret with wet into wet and you need to work quickly. To buy more time, wet the paper first with clean water. The paper should glisten but there should be no pools or puddles on the surface, so remove the excess water using a damp, clean brush.

Chinese landscape

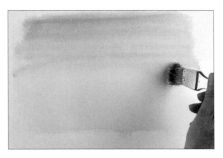

1. Wet the paper first with the golden leaf brush, then paint a wash of ultramarine with horizontal strokes from the top. While this is wet, paint a wash of raw sienna from the bottom.

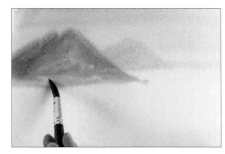

2. Use the large detail brush to paint a distant mountain on the wet background with cobalt blue, then paint a nearer mountain with burnt umber and cobalt blue.

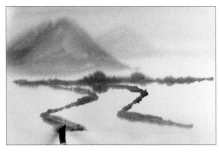

3. Use a thicker mix of the same colours to paint the hedgerow and its reflection, and the river's edges.

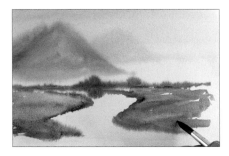

4. Fill in the land beside the river with the same mix.

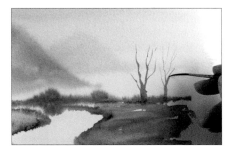

5. Paint distant tree shapes with the half-rigger.

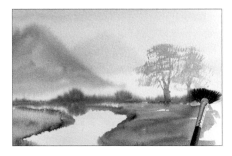

6. Change to the fan gogh brush and paint the foliage with a pale mix of the same colours. Tap and drag the brush over the background, leaving some showing through.

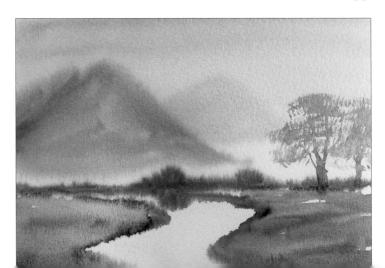

The finished painting.

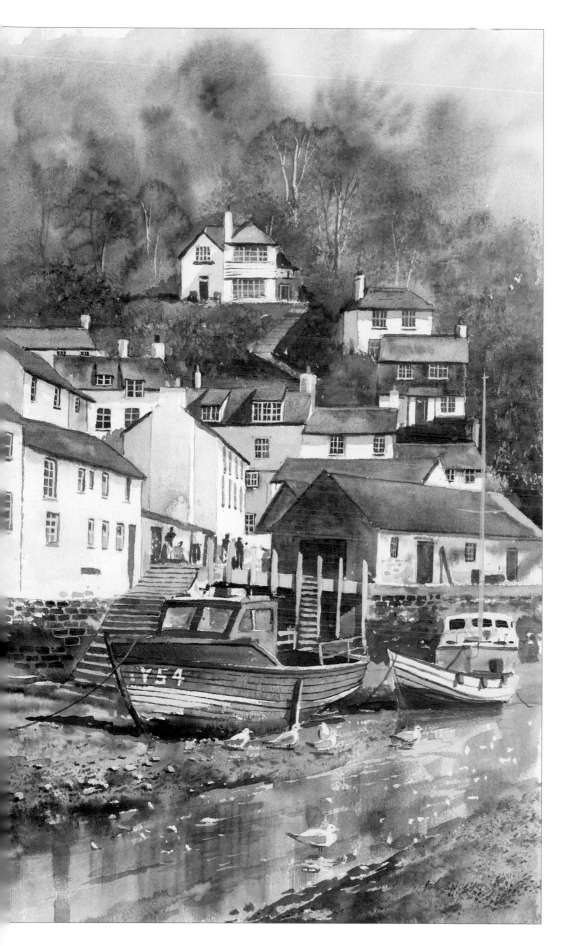

Fisherman's Creek, Polperro

The distant trees and foreground were painted on to a previously wet surface, but the buildings were painted on a dry background, so the trees appear soft and misty, while the buildings have a hard edge. The rooftops were painted one at a time after the background trees had dried to avoid the roofs bleeding into the background. With small areas like the roofs, there is no need to pre-wet the surface, just paint in the first colour then drop the second colour into the first whilst it is still wet.

Wet into wet sunset

1. Wet the paper first with the golden leaf brush. Paint a wash of cadmium yellow with a touch of permanent rose across the bottom half of the sky.

2. While this is wet, paint permanent rose in the middle part of the sky.

3. Paint the top of the sky with cobalt blue, blending it into the permanent rose.

4. While the sky is wet, dab in clouds with shadow colour.

5. Use the large detail brush and shadow colour to paint pale, distant mountains.

6. Suggest a forest at the foot of the mountains with a thicker mix of ultramarine and burnt umber.

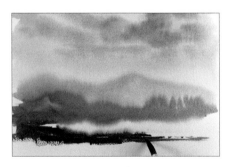

7. Wet into wet is an unpredictable technique, and sometimes happy accidents occur. In this case, the forested area looked as though it was reflected in a lake, so going with the flow, I painted a near shore to the lake with a browner mix of the same colours.

8. Touch colour into the lake with a mix of cadmium yellow and permanent rose, to reflect the sky colours. Now allow to dry naturally, so that the colours continue to soften and merge.

9. Now that the painting is dry, take the half-rigger and paint a winter tree with the burnt umber and ultramarine mix. Waiting until the background has dried creates a sharp- edged tree which contrasts well with the soft, misty background.

The finished sunset.

Summer Reflections

The wet into wet technique is well suited to painting the background trees and soft reflections in water. This must be allowed to dry before painting in the other trees and grasses on the riverbank. The hard-edged trees and grasses are clearly in the foreground whilst the misty trees appear to recede into the distance.

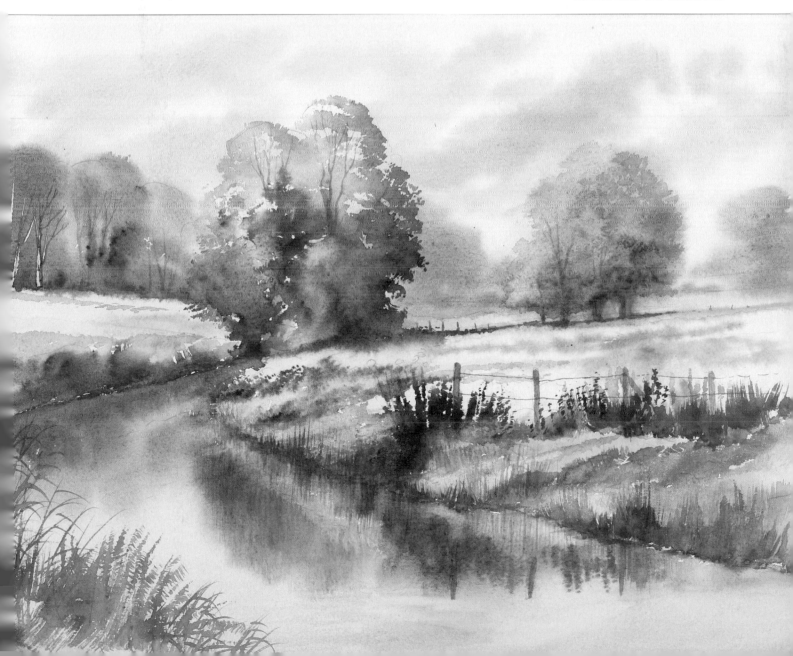

Wet on dry

Wet on dry simply means painting wet paint on to a dry surface. This will result in a hard edge. Any detail can be added to a dry surface and the paint will remain crisp and defined and not dissolve into the background.

1. Wet the background with the golden leaf brush, then paint a thin wash of raw sienna in the lower part of the sky. Drop in cobalt blue from the top, creating cloud shapes, and allow to dry.

2. Use the large detail brush with a pale mix of cobalt blue to paint the horizon. Wash the brush and run clean water along the bottom of the horizon line to soften it. Dry with a hairdryer.

3. Make a stronger wash of cobalt blue, and paint the next row of mountains coming forwards, working on the dry background to create a crisp line.

4. Wash the brush and run it over the base of the still wet mountains to create a misty effect in the valley, contrasting with the crisp line of the mountain tops. Dry with the hairdryer.

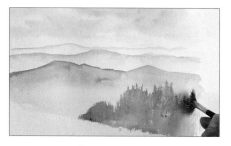

5. Paint the nearer mountains in the same way with cobalt blue and midnight green. Make a stronger, greener mix and paint the forested area using the fan stippler on its side to create the fir tree tops.

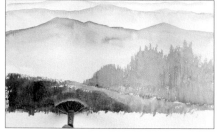

6. Paint the foreground with country olive, still using the fan stippler, then add midnight green on the left.

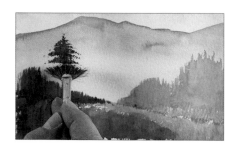

7. Use the fan stippler on its side to paint the trunk of a pine tree, then use the curved edge of the brush to paint the branches.

The finished landscape.

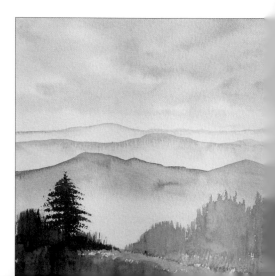

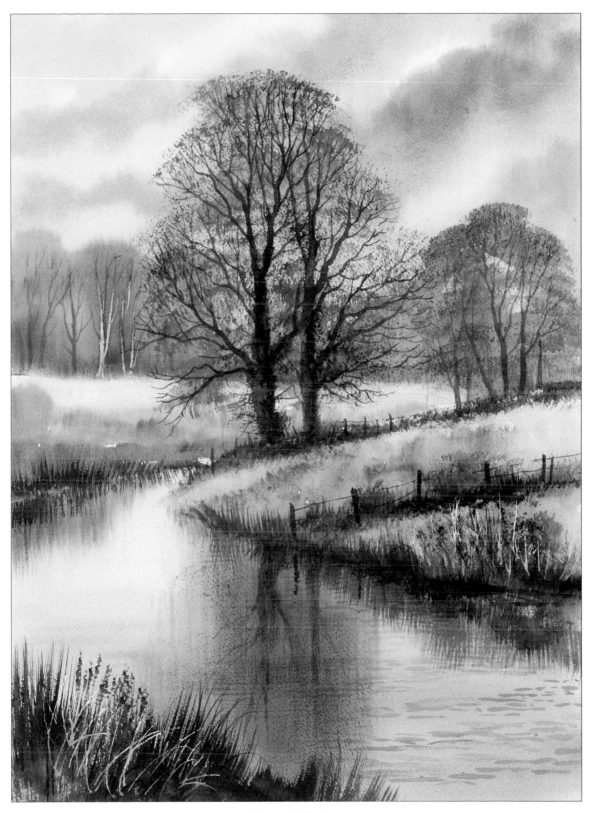

Winter Reflections

This riverside view combines wet into wet and wet on dry techniques, as with most watercolour paintings. Misty trees in the distance were painted wet into wet and stronger, more defined trees in the middle distance and detail in the foreground were painted wet on dry.

Dry brush work

This is a simple technique for creating texture, which works best on Rough paper. Drag the almost dry brush over the surface of the paper, allowing the paint to catch on the raised texture of the paper.

Tree trunks

1. Paint the tree trunks with the large detail brush and a mix of raw sienna and country olive. Allow to dry.

2. Wash the brush in clean water then blot in on kitchen paper to dry it before picking up paint.

3. Pick up a thick mix of burnt umber and country olive and drag the brush on its side, over the paper surface to create the bark texture.

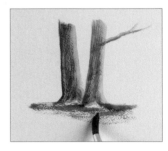

4. Drag the brush over the ground to create texture in the same way.

Reflected mountains

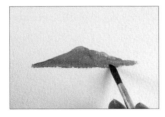

1. Use the medium detail brush and shadow colour to paint the distant mountain.

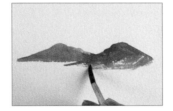

2. Pick up a browner mix of burnt umber and ultramarine to paint the nearer mountain. Use dry brush work to create a little texture.

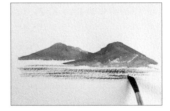

3. Rinse and then dry the brush on kitchen paper. Use it on its side with ultramarine to paint the water. The white paper showing through suggests sparkling water.

4. Use the ultramarine and burnt umber mix and more dry brush work to suggest the reflection of the nearer mountain.

5. Add detail to the mountain with the same mix and more dry brush work.

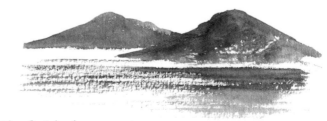

The finished mountains.

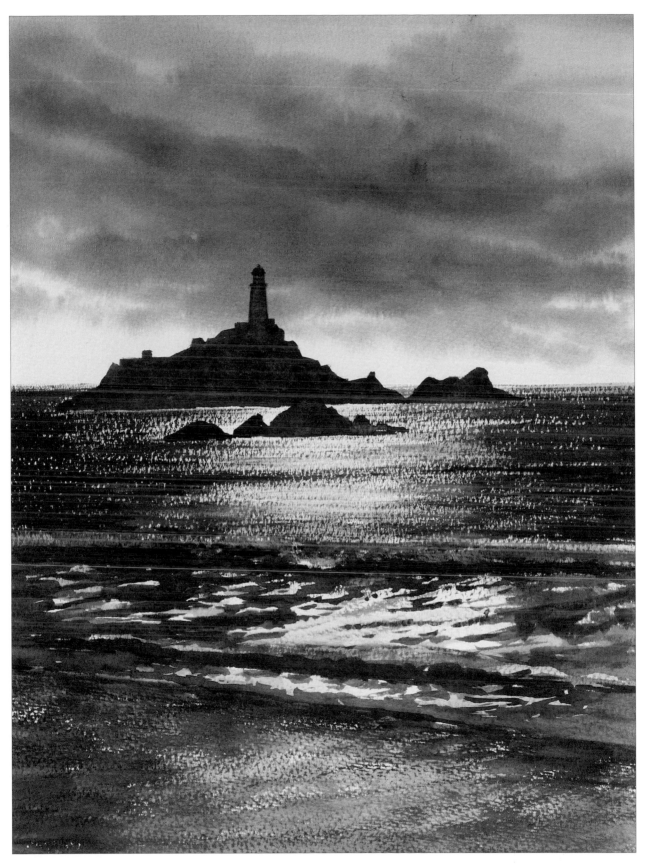

Shimmering Sea
The bright sparkly light on the water is highlighted by the strong darks of the offshore rocks and lighthouse. A good quality Rough paper is ideal for this technique.

Masking fluid

Masking fluid features quite heavily in my paintings. I would be lost without it, but a little care is needed to get the most from your masking fluid. Apply it only to dry paper, don't apply it too thickly, don't leave it on your paper for more than three or four days (or it becomes difficult to remove), and replace the lid immediately after use. If the fluid is thick, sticky and difficult to remove, it might have gone off, so replace it. Wipe your brush with soap before dipping it into the masking fluid; this will form a barrier between the brush hair and the masking fluid.
There are a lot of don'ts, but don't let that put you off using it.

A window

1. Mask the whole window frame with masking fluid.

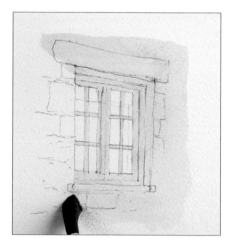

2. Paint the stonework around the frame with the large detail brush and a wash of raw sienna.

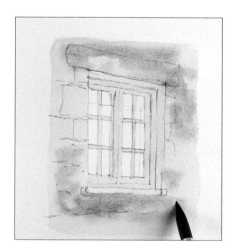

3. While the first wash is wet, drop in burnt sienna to warm the stone colour.

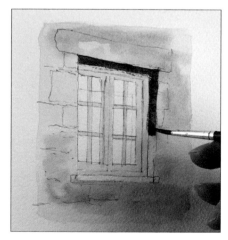

4. Mix shadow and burnt sienna and use the small detail brush to paint the dark shadow in the window recess.

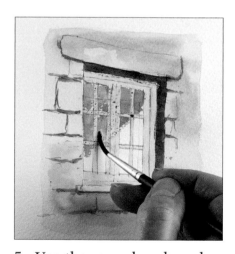

5. Use the same brush and mix to paint the shadowed edges of the stones. Then paint a diagonal reflection in the glass with cobalt blue, painting over the masking fluid.

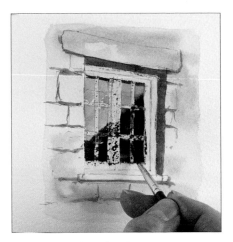

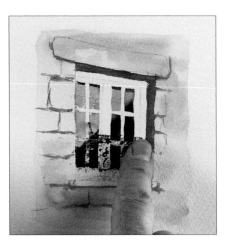

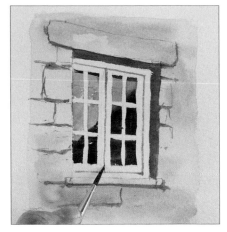

6. Paint the darker area of the window with a mix of ultramarine and burnt umber. Allow to dry.

7. Rub off the masking fluid with a clean finger.

8. Use the half-rigger and a dark mix of ultramarine and burnt umber to paint details on the woodwork. Allow to dry.

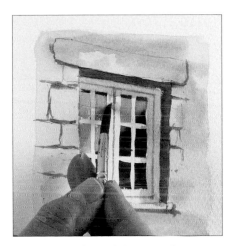

9. Mix cobalt blue with a touch of shadow and paint the shadow cast by the stonework on the window frame.

The finished window.

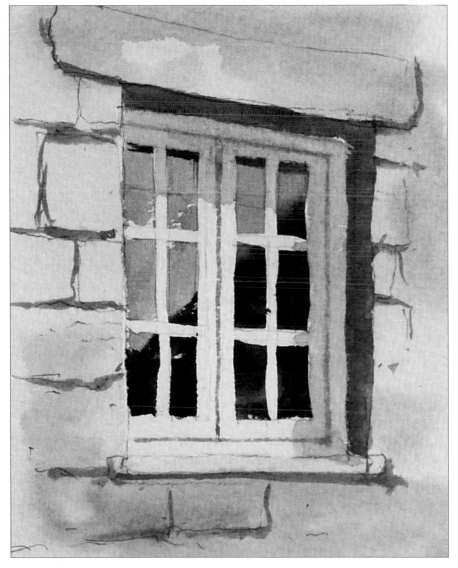

71

Masking flowers

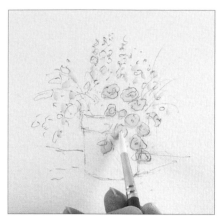

1. Mask the flowers and allow the masking fluid to dry.

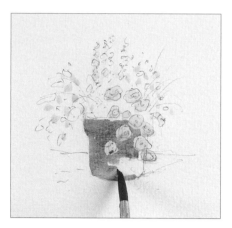

2. Paint the plant pot with the medium detail brush and burnt sienna. Allow to dry.

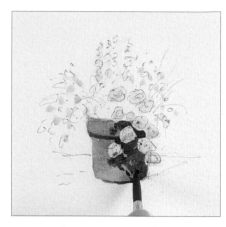

3. Working wet on dry, paint the shaded side of the pot with shadow colour.

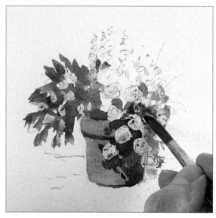

4. Paint some of the foliage with midnight green, going over the masked flowers in places.

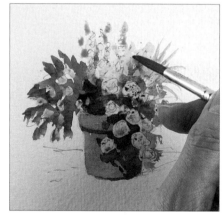

5. Working wet into wet, paint lighter foliage with sunlit green. Allow to dry.

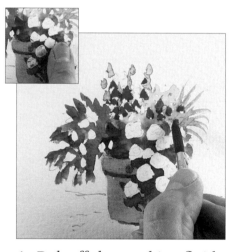

6. Rub off the masking fluid with a clean finger. Paint some of the flowers with cadmium red.

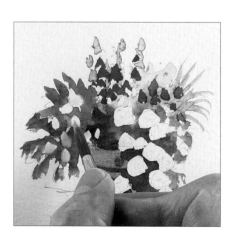

7. Paint more flowers in cadmium yellow.

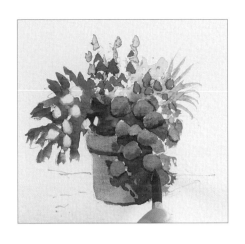

8. Use a thin wash of permanent rose to paint the final flowers, then while this is wet, drop in a thicker mix of the same colour.

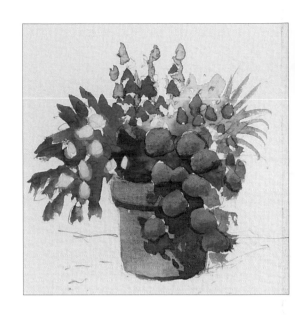

The finished flowers.

Sunday Cricket

What a perfect way to spend a Sunday afternoon, sitting in the shade, relaxing and watching cricket, or on the other hand, you could be painting. This is a good example of when to use masking fluid. Carefully draw the cricketers, and mask each player. The cricket green can then be painted over the figures to produce an even wash. When this is dry, remove the masking fluid and add the detail on the cricketers. Masking fluid can also be used for any flowers and grasses in the foreground.

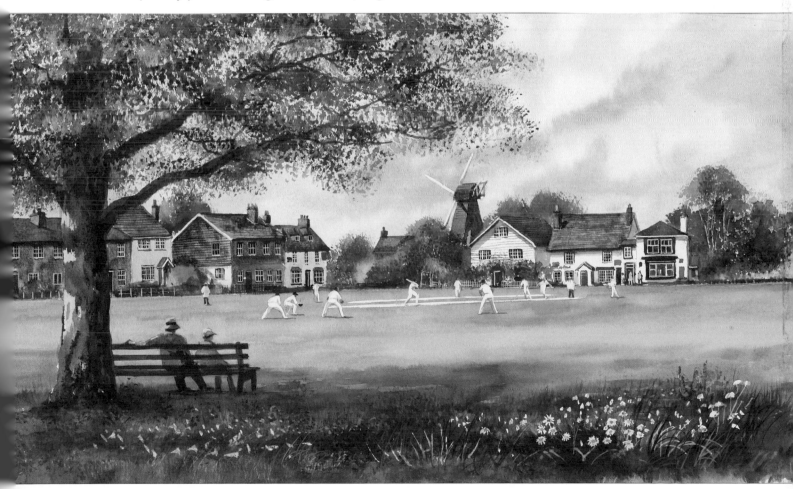

Applying masking fluid with kitchen paper

A snow-covered tree

1. Dip a scrunched up piece of kitchen paper in a saucer of masking fluid, and use it to dab the fluid on to the tree tops to suggest snow.

2. Use a brush to apply more masking fluid, suggesting snow on some of the branches. Allow to dry.

3. Use the large detail brush to paint a wash of ultramarine for the sky, over the masking fluid. Allow to dry.

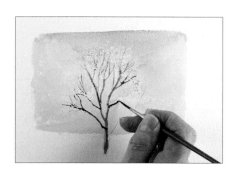

4. Change to the half-rigger brush and use a mix of burnt umber and ultramarine to paint the trunk and branches. Allow to dry.

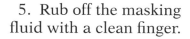

5. Rub off the masking fluid with a clean finger.

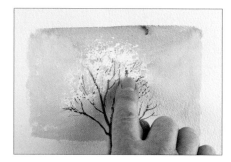

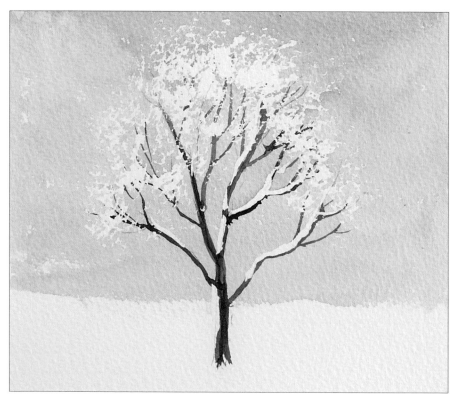

The finished tree. This method of applying masking fluid creates a textured effect that lends itself well to snow clinging to the branches.

A breaking wave

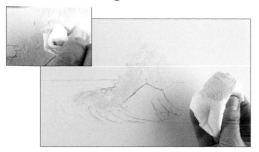 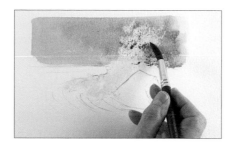 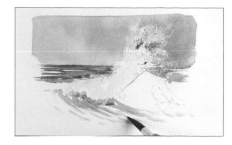

1. Make a pad with kitchen paper and pick up some masking fluid from a saucer. Dab it on to the painting to create the foam from the crashing wave. Allow to dry.

2. Use the large detail brush to paint the sky with ultramarine, and while this is wet, drop in burnt umber and ultramarine to suggest stormy clouds.

3. Paint the distant sea with a mix of ultramarine and midnight green using horizontal strokes. Then paint the foreground, making strokes in the direction of the wave.

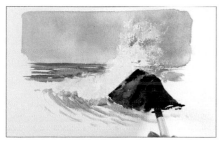 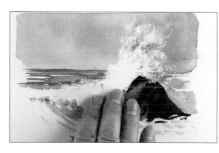 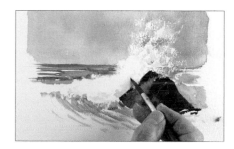

4. Paint the rock with burnt umber, then drop in burnt umber and ultramarine for the darker parts. Allow to dry.

5. Remove the masking fluid by rubbing with clean fingers.

6. Use the medium detail brush and a thin wash of cobalt blue to paint a little shading on the foam.

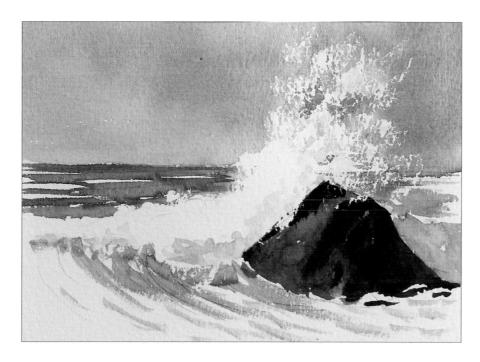

The finished wave.

Final touches

Adding life

Many years ago an artist suggested I should always include something living in my paintings. I sometimes add subjects such as cows grazing, sheep in a field, a horse in a meadow, or just some birds in the sky. Adding life also emcompasses objects such as carts and farmyard clutter, as they add interest and might fill a void in your painting. Often at the end of a painting you might feel it just needs something to finish it off. Here are a few ideas to help you, but why not keep a sketchbook or a file full of photographs to inspire you.

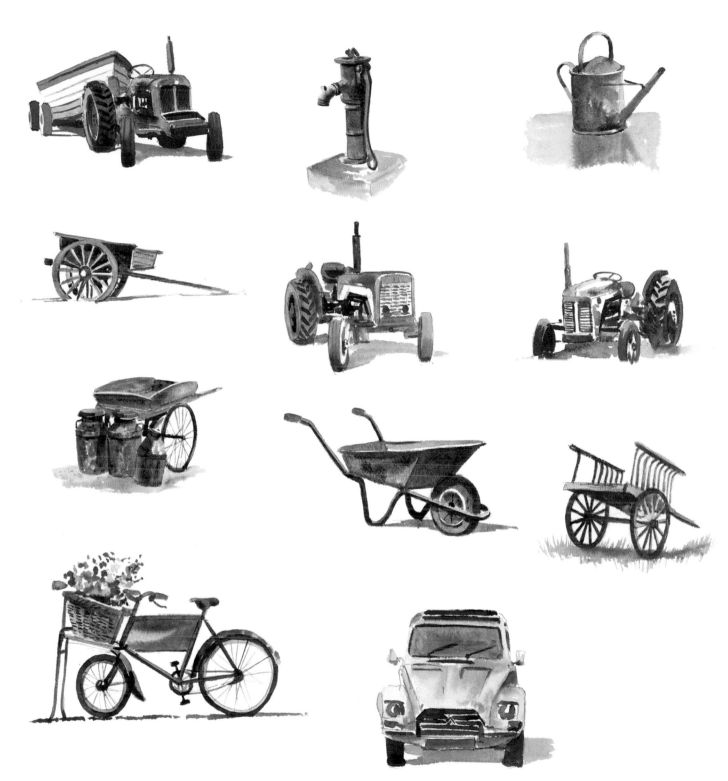

Overleaf
Norfolk Sunset
*I painted this sunset as a
simple landscape, but felt that
it needed something else. Then I
remembered seeing a horse and
cart on the sands of a Norfolk
beach as a child, and so I added
this to complete the picture.*

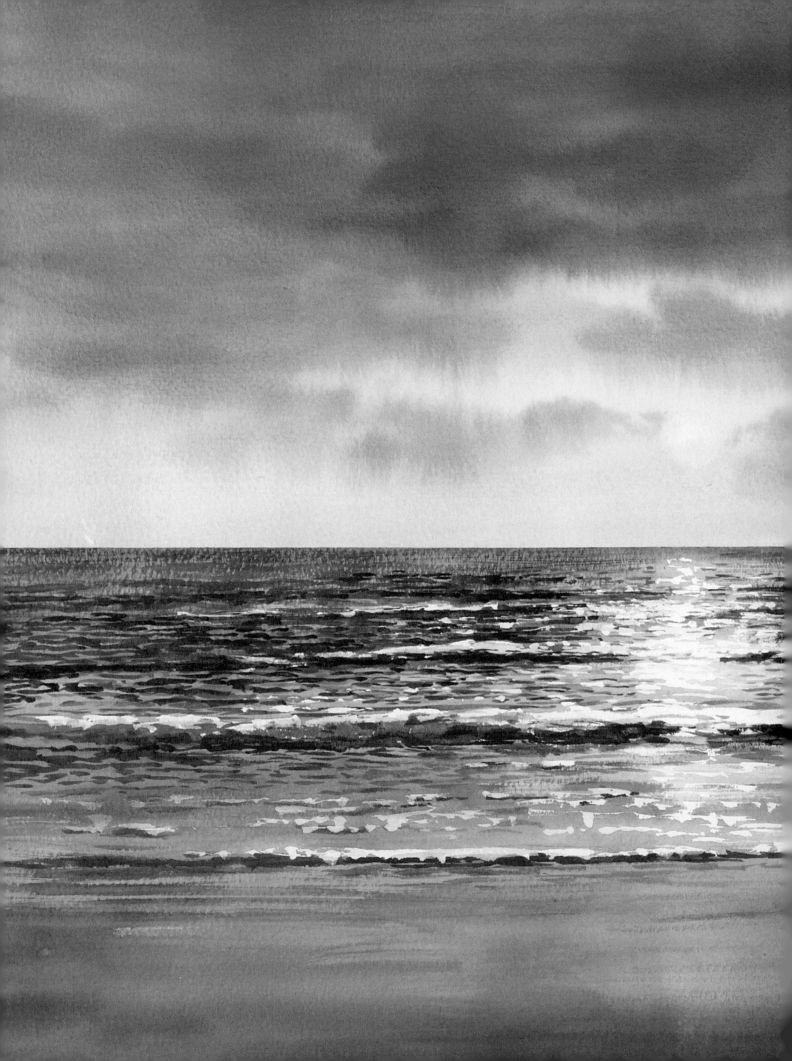

DEMONSTRATIONS

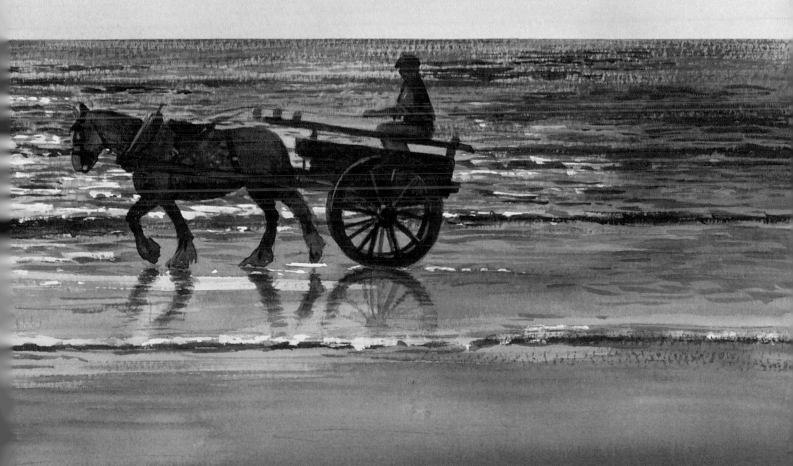

Venetian Doorway

To keep this Venetian scene simple, I have chosen a square-on view so I do not have to worry about the perspective. This step-by-step demonstration offers an opportunity to create plenty of interesting textures such as crumbling plaster and brickwork. A splash of colour is added to the window boxes. This scene could be any canal-side building, but just by adding the shape of a gondola in the foreground, we have established that this is Venice.

You will need

2B pencil

Masking fluid and masking fluid brush

Golden leaf, foliage, half-rigger, medium detail, small detail and emperor 19mm (¾in) flat brushes

Paints – see page 16

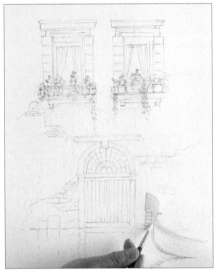

1. Draw the scene with a 2B pencil. Mask the flowers and the boat with masking fluid and a masking fluid brush.

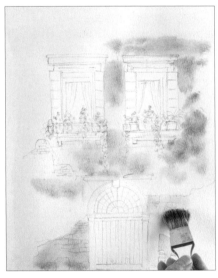

2. Wet the wall with the golden leaf brush and clean water, then drop in raw sienna. While this is wet, drop in burnt sienna.

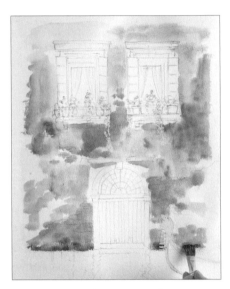

3. Drop in burnt umber, then use the foliage brush to add touches of shadow, then cadmium red and burnt sienna. Add midnight green along the waterline. Allow to dry.

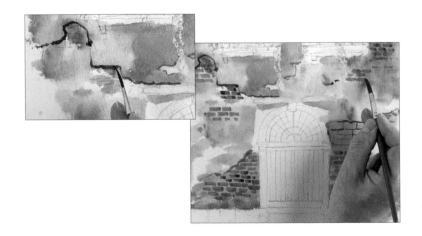

4. Use the half-rigger and shadow to paint round the edges of the cracked plaster. Suggest bricks with the medium detail brush and burnt sienna.

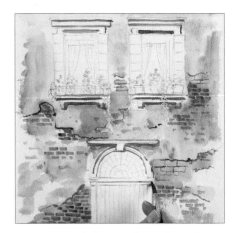

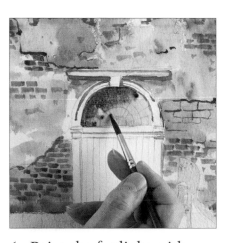

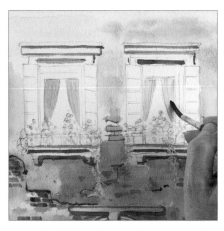

5. Paint the window lintels and sills and the detail above the fan light with shadow and burnt sienna.

6. Paint the fanlight with cobalt blue and a touch of burnt umber. Drop in a darker mix while this is wet.

7. Block in the curtains with a wash of raw sienna and allow to dry.

8. Use the small detail brush and a mix of burnt umber and ultramarine to paint the details of the curtains.

9. Paint the top parts of the windows with cobalt blue, then mix in burnt umber to paint the lower parts, going down over the masked flowers.

10. Darken the edges of the windows with the medium detail brush and a mix of burnt sienna and ultramarine. Paint darker shadows at the top with ultramarine and burnt umber.

11. Paint the shutters and then the door with a mix of cobalt blue and midnight green. While the green is wet, drop in raw sienna at the bottom. It will push up into the background colour, giving the door a weathered look. Allow to dry.

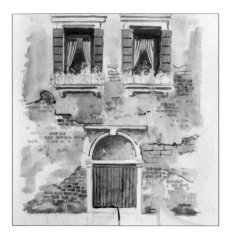

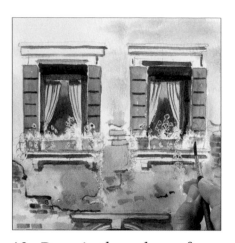

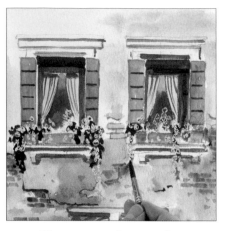

12. Use the half-rigger and burnt umber to paint detail on the shutters and door.

13. Drop in the colour of the window boxes with the small detail brush and burnt sienna. Allow to dry.

14. Change to the medium detail brush and paint the foliage in the window boxes with midnight green.

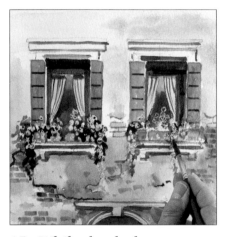

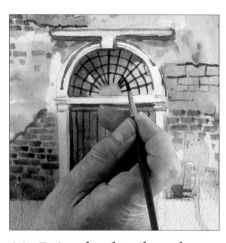

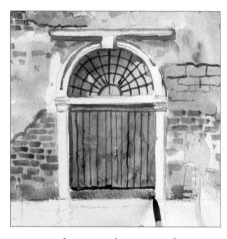

15. While the dark green is wet, dot in sunlit green for the brighter parts of the foliage.

16. Paint the detail on the fan light with the small detail brush and a mix of ultramarine and burnt umber.

17. Make a pale mix of burnt umber and use the medium detail brush to paint the doorstep.

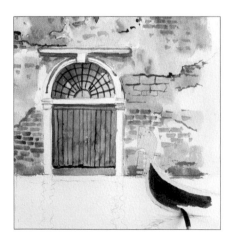

18. Paint the gondola with ultramarine and burnt umber.

19. Take the 19mm (¾in) flat brush, pick up cobalt blue and midnight green and paint the reflection of the door with a zigzagging side-to-side motion.

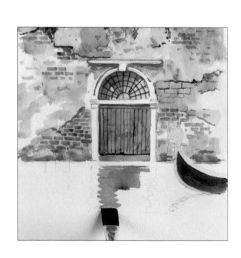

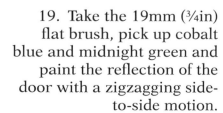

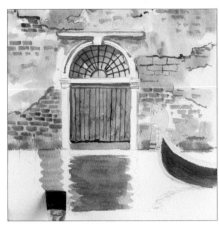

20. Make a pale mix of burnt sienna with a little cobalt blue and paint a reflection of the wall in the same way.

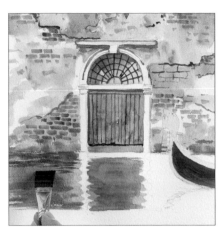

21. Continue painting the reflection, and add country olive to reflect the water-stained part of the wall.

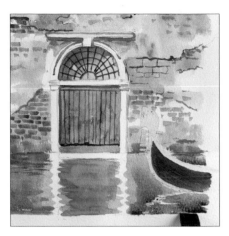

22. Paint the reflections on the right in the same way, then paint the reflection of the gondola with cobalt blue and burnt umber.

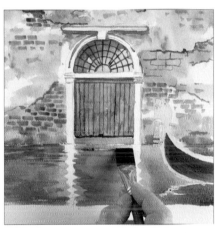

23. Paint the reflection of the doorstep with burnt umber and a touch of cobalt blue. Allow to dry.

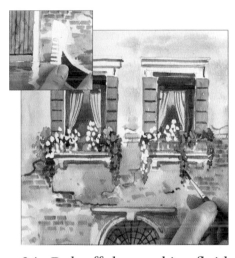

24. Rub off the masking fluid with clean fingers. Use the small detail brush to paint some of the flowers with permanent rose.

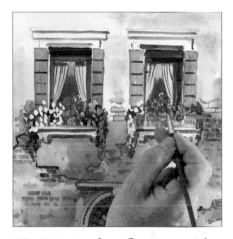

25. Paint other flowers with a thin mix of cadmium red, then, while this is wet, drop in a thicker mix.

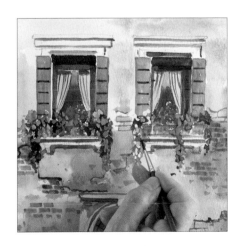

26. Paint the last flowers with a mix of cobalt blue and permanent rose.

27. Make a very pale wash of cobalt blue and use this to paint the outer parts of the gondola with the medium detail brush.

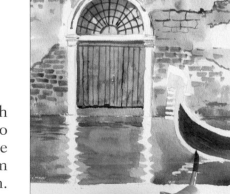

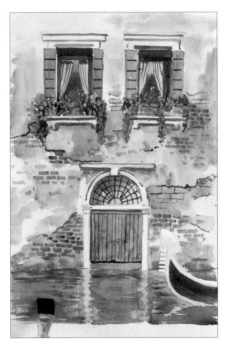

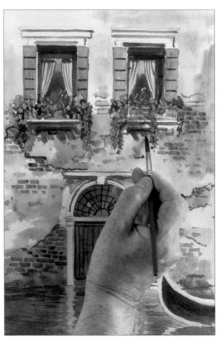

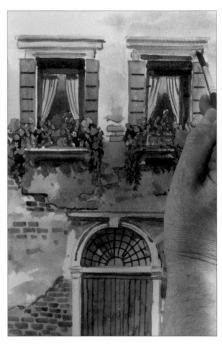

28. Add a touch of burnt sienna to the cobalt blue wash and use the 2cm (¾in) flat brush to paint over the white parts of the reflection, then add horizontal ripples.

29. Change to the medium detail brush and paint dappled shade under the window boxes with shadow colour.

30. Take the white out of the window lintels by painting on a wash of burnt sienna.

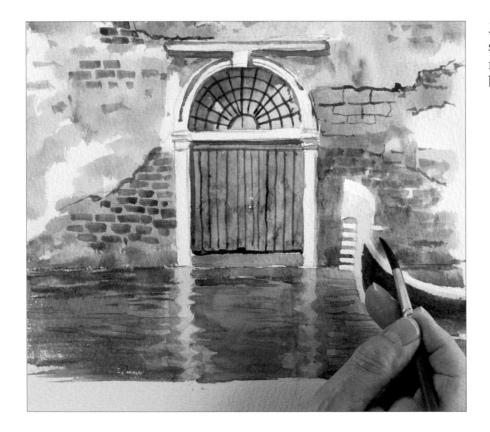

31. Finally paint burnt sienna behind the gondola to make it stand out from the background.

Opposite
The finished painting.

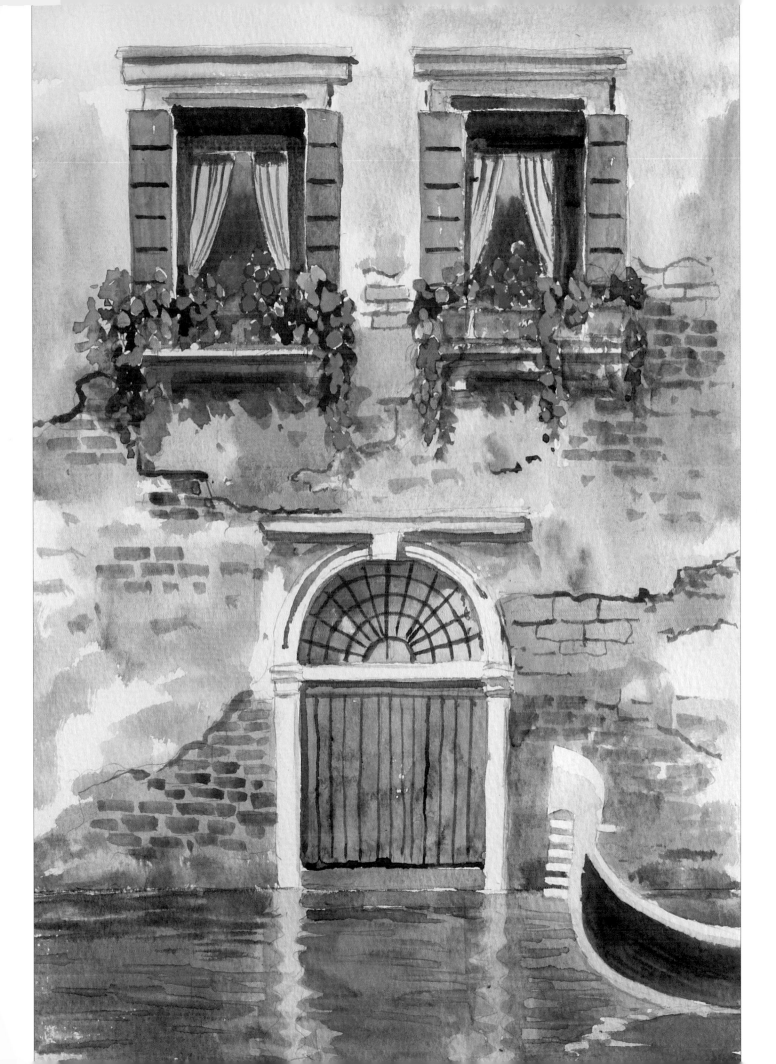

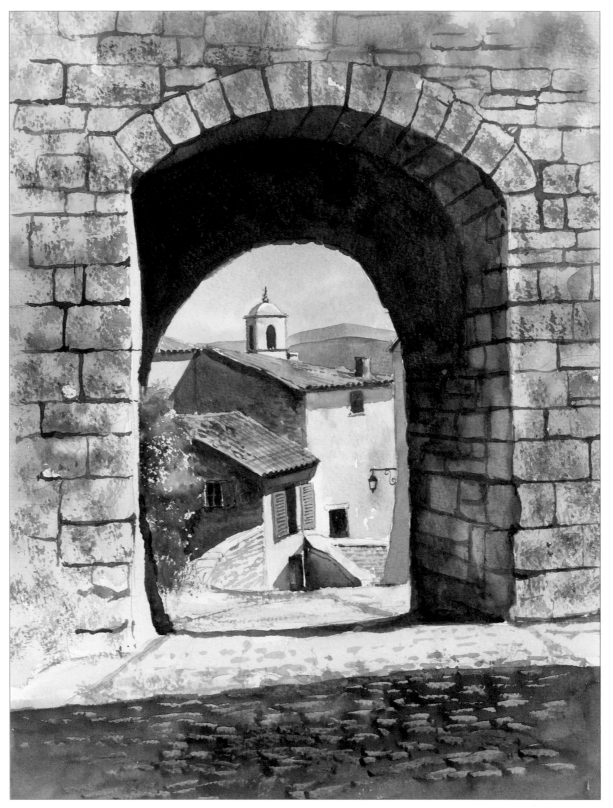

Provencal Archway

The viewer is drawn to the centre of this warm, sunlit French street scene and is invited to pass through the archway and explore the streets beyond. Strong tonal contrasts are used to create the sunshine and shade. Notice the reflected light on the wall on the inside of the arch. All the texture on the stonework was painted using the stippler px and the cobbles in the shady foreground were scraped away using the px handle.

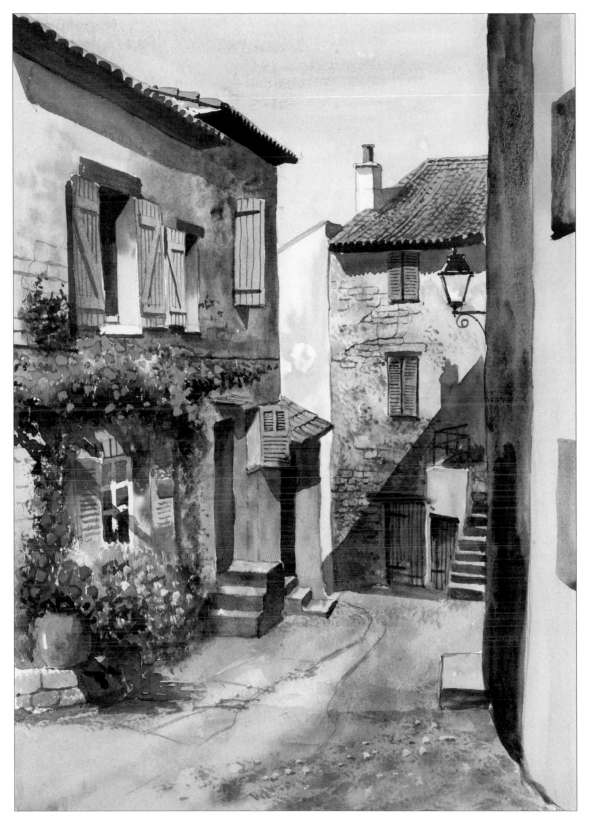

Back Street Blooms

*I love exploring the little back streets and alleys of quaint hilltop villages
in the South of France. Turn a corner and you are greeted with a blaze of
colour. Even if the street you see is plain, colourful flowers and shutters
can be added in the painting to enhance your memories.*

St Lucia Beach

Painting on holiday sounds like a good idea, but in practice, it is not easy. The minute you set up your easel and get out your paints, a small crowd appears from nowhere and there is no easy way to tell people to leave you alone. The answer is to take lots of photographs and combine them into a composite painting that will remind you of the holiday. This beach scene is one such painting, pulling together special memories such as the rustic boat shed, the traditional St Lucian fishing boat on a sandy beach, the turquoise-coloured sea lapping at your feet and the palm trees swaying in a cool breeze.

You will need

2B pencil

Masking fluid and masking fluid brush

Golden leaf, stippler px, large detail, medium detail, half-rigger, small detail, fan gogh and foliage brushes

Kitchen paper

Paints – see page 16

1. Draw the scene with a 2B pencil. Use masking fluid with a special brush to mask the verandah, sailing boat, waterline, planks leaning against the shack and some of the stones.

2. Wet the sky area with the golden leaf brush and clean water, then paint a wash of cobalt blue from the top. While this is wet, use kitchen paper to lift out cloud shapes.

3. Use the stippler px with midnight green and cobalt blue to stipple trees, using a paper mask to create the line where the trees meet the beach. While this is wet, drop in sunlit green.

4. Mask the edges of the shack and continue creating foliage around it in the same way, with midnight green and sunlit green on the stippler px.

5. Paint the beach with the golden leaf brush and raw sienna, taking the mix into the edge of the surf. While this is wet, paint a thin wash of burnt sienna just above the waterline.

6. Use the large detail brush to paint a wash of cobalt blue at the top of the water area.

7. Paint the rest of the sea area with turquoise.

8. Block in the rusty tin roof with burnt sienna, then drop in burnt umber wet into wet.

9. Paint the shack with a pale wash of raw sienna, then drop in cobalt blue while this is wet.

10. Use burnt sienna to paint the side of the shack, then drop in shadow wet into wet, creating an uneven effect. Allow to dry.

11. Take the medium detail brush and a mix of ultramarine and burnt umber and paint the shade under the eaves and the verandah, and the darks of the door and windows.

12. Change to the half-rigger and use the same mix to paint the boards of the shack walls and the detail of the roof.

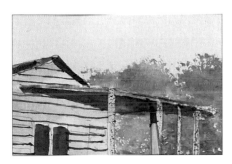

13. Use the small detail brush to paint the top of the verandah with burnt sienna.

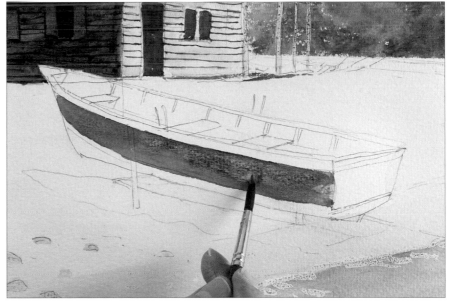

14. Paint the side of the boat with the medium detail brush and cobalt blue with a touch of burnt sienna. Drop in raw sienna wet into wet, to create a textured, weathered look.

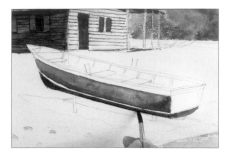

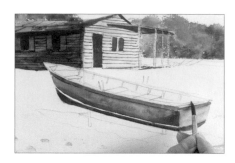

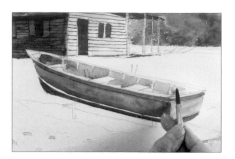

15. Darken the lower edge of this side with a darker mix of cobalt blue and raw umber, then paint cadmium red and burnt sienna on the base of the boat, leaving a white line.

16. Paint the top rim of the boat with cadmium red, and the stern with cobalt blue, then wash the inside with cadmium yellow and allow it to dry.

17. Use shadow to paint the shaded parts of the boat's inside, making it darker towards the prow. Allow to dry.

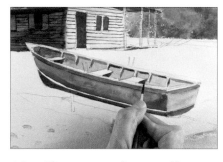

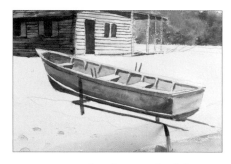

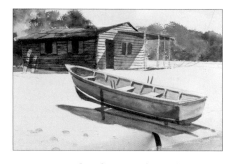

18. Change to the small detail brush and a darker mix of shadow, and paint the deeper shading under the gunnel and seats.

19. Paint the frame holding the boat with the medium detail brush and burnt umber. Allow to dry.

20. Use the large detail brush and shadow to paint the shadow under the verandah, to the left of the shack and under the boat.

21. Paint the shaded sides of the masked stones with the small detail brush and shadow.

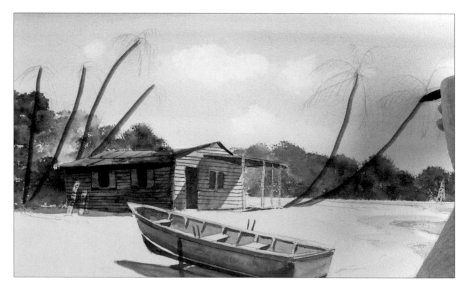

22. Use the large detail brush and a mix of burnt umber and ultramarine to paint the palm trunks with sweeping, upward strokes.

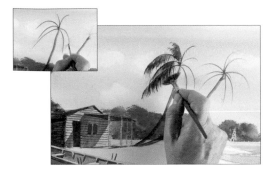

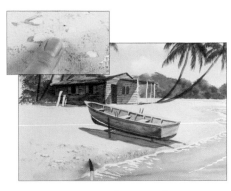

23. Use the half-rigger and midnight green to paint the stalks of the palm leaves, then use the fan gogh brush to paint the fronds, brushing downwards and using the shape of the brush.

24. Stipple texture into the sand at the water's edge with the foliage brush and shadow. Allow to dry.

25. Remove the masking fluid by rubbing with clean fingers. Paint a light wash of raw sienna over the newly revealed white of the stones on the beach using the large detail brush.

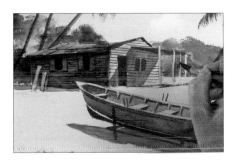

26. Paint a thin wash of burnt umber over the planks and verandah uprights.

27. Use the small detail brush to paint the sailing boat with cadmium red.

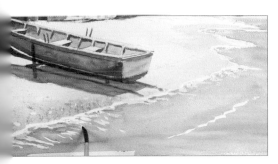

28. Use a thin wash of cobalt blue and the medium detail brush to paint shade in the white of the surf.

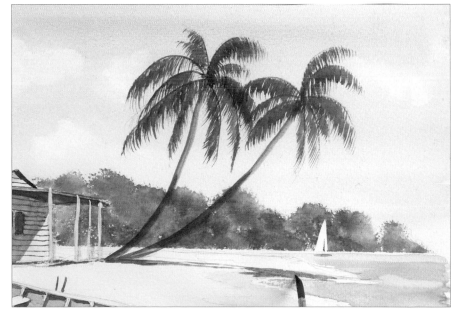

29. Finally paint the cast shadows from the palm trees with the shadow colour.

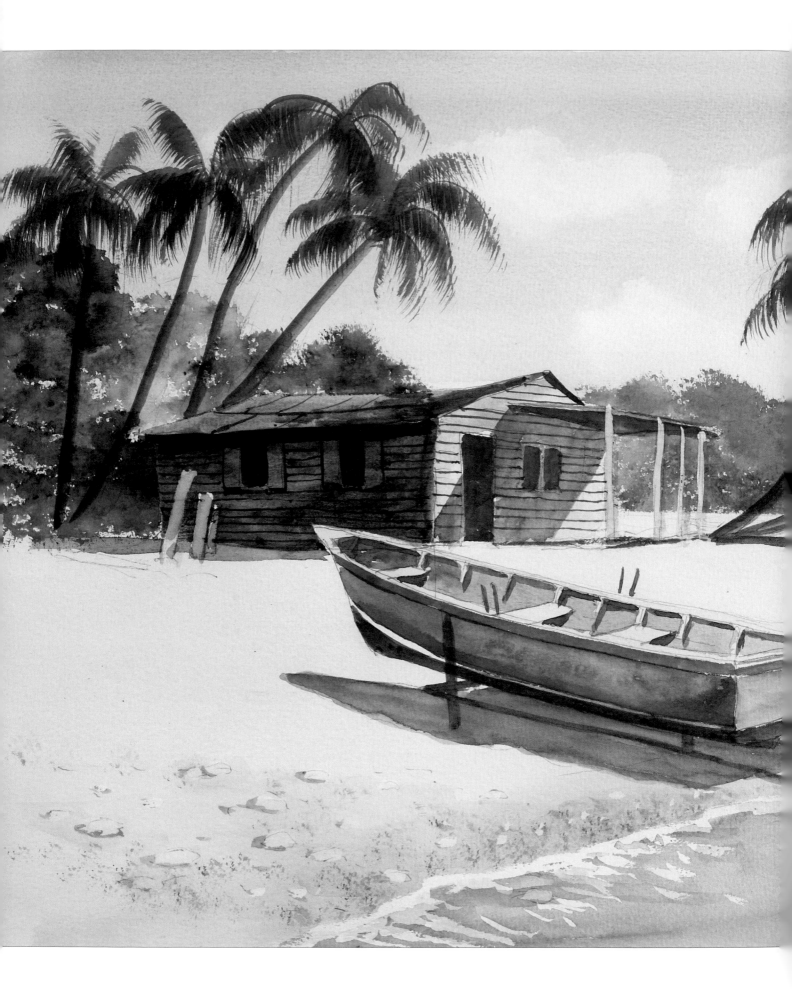

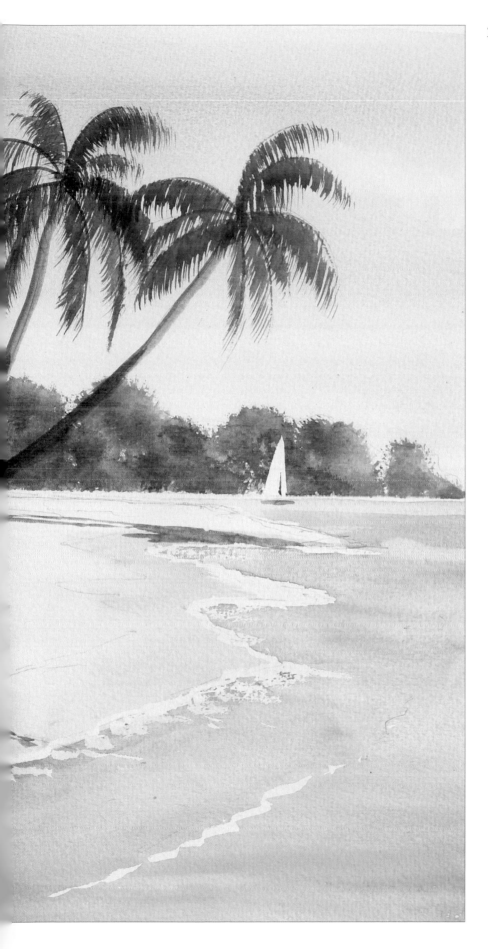

The finished painting.

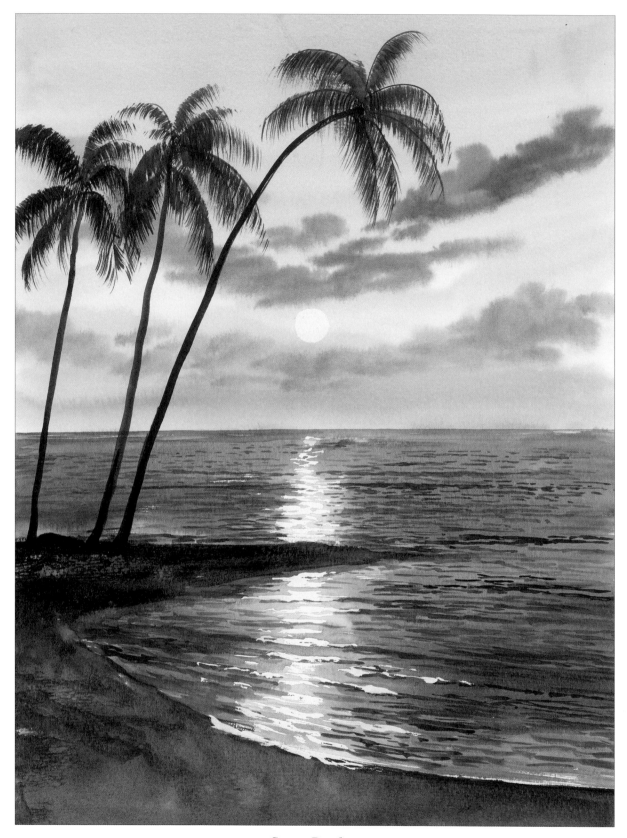

Sunset Beach

There is nothing much better than walking on the beach at sunset, apart from painting the sunset! The sun was created using a small coin tightly wrapped in kitchen paper and stamped on to the still wet sky. The rippled reflections of the sun on the water were masked out using masking fluid.

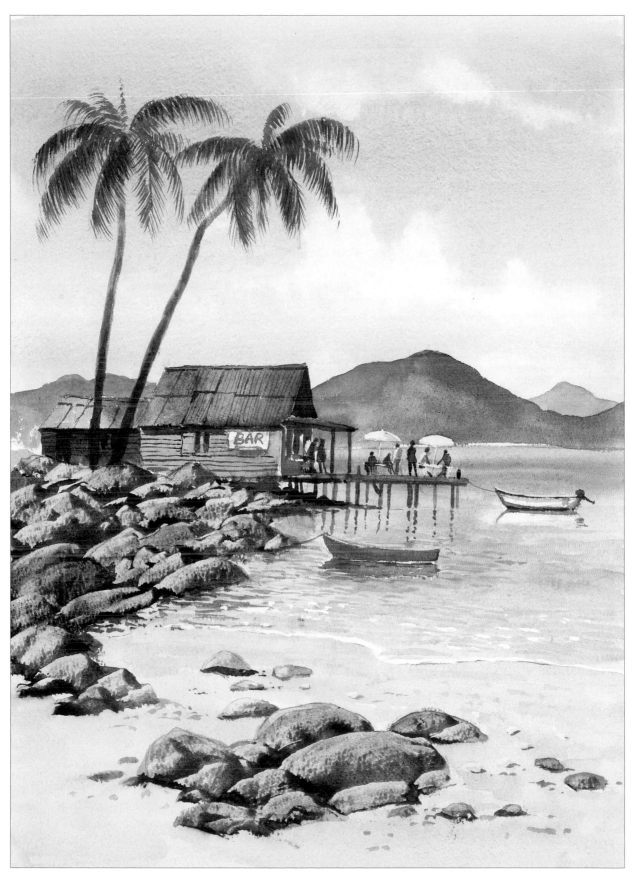

Beach Bar
When choosing a subject, think of a place where you would want to be!

Barn in Snow

This snow scene includes one of my favourite subjects to paint, a barn. Masking fluid plays an important part in this painting. The light dusting of snow over the trees was created by dabbing masking fluid over the trees with some kitchen paper, a very simple and effective technique. The dark trees at the back of the barn help to define the roof shape.

You will need

2B pencil
Kitchen paper
Masking fluid and masking
fluid brush
Scrap paper for paper mask
Golden leaf, foliage,
fan stippler, stippler px,
large detail, half-rigger,
medium detail,
small detail and
fan gogh brushes

1. Draw the scene with a 2B pencil.

2. Make a pad from kitchen paper and dip it in masking fluid. Dab it gently on to the paper to suggest snowy treetops. Do this against a paper mask to create the edge of the barn.

3. Use the masking fluid brush to mask some of the branches, the stile and the fence to make them snow-capped. Add more masking fluid to the track.

4. Paint the lower sky with raw sienna, using the golden leaf brush.

5. Drop in ultramarine wet into wet, allowing some of the previous wash to show.

6. Stipple on distant hedgerows using the foliage brush with a mix of shadow and cobalt blue and a paper mask held at various angles, suggesting a patchwork of distant fields.

7. Stipple ivy on the tree trunks with the fan stippler and midnight green.

8. Use the same brush and a mix of burnt sienna and shadow to stipple the texture of the winter branchwork, working over the masking fluid.

9. Change to the stippler px and stipple the same colour for the trees on the left, using a paper mask to mask the edge of the barn. Change the angle of the paper mask as you continue creating the barn.

10. Use a torn edge to help you stipple the nearer hedgerow with more burnt sienna in the mix.

11. Use the golden leaf brush and freehand stippling with the shadow and burnt sienna mix to suggest foliage at the top of the painting.

12. Paint the side of the barn with the large detail brush and raw sienna and a touch of sunlit green, then while this is wet, drop in burnt umber and ultramarine under the eaves.

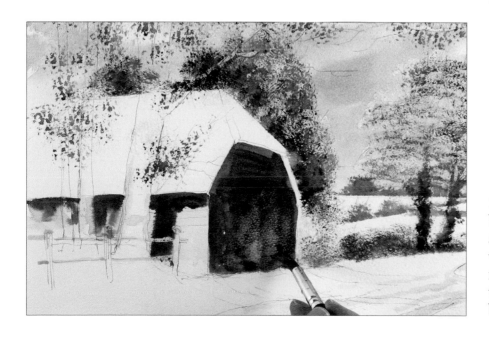

13. Paint the front of the barn with country olive and burnt umber, and while this is wet, drop in raw sienna. This creates a textured effect, making the barn look weathered.

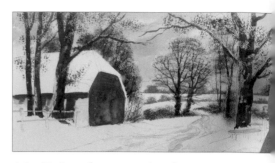

14. Use the half-rigger and a mix of burnt umber and shadow to paint the branches of the ivy-covered tree, working upwards.

15. Paint more tree trunks, with burnt umber and shadow, using a combination of the medium detail brush and the half-rigger.

16. Paint the trees in the foreground with the large detail brush and burnt umber and country olive. Make sure the undersides of the masked branches are dark, for contrast.

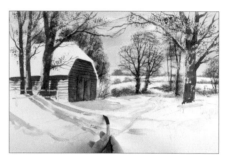

17. Use the same colour and the small detail brush to paint the finer branches and twigs.

18. Paint the details of the barn's woodwork with burnt umber and ultramarine.

19. Use the large detail brush to paint cobalt blue shadows on the snow, indicating the shape of the ground by their slope.

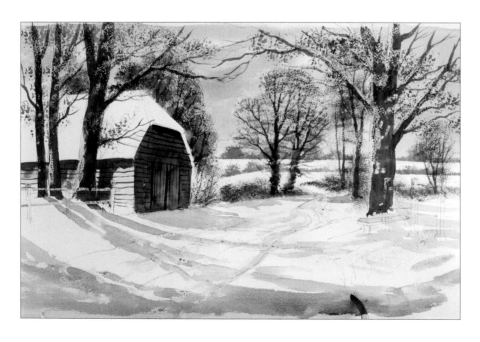

20. Add a little shadow to the cobalt blue wash and paint shadows in the foreground coming from something outside the frame of the scene. This stops the eye from drifting off the bottom of the painting.

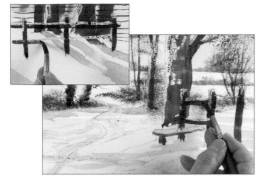

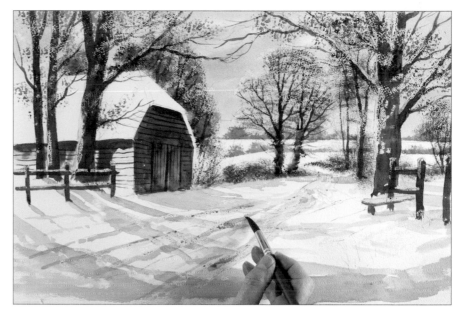

21. Paint the woodwork of the fence and the stile, going over the masking fluid with a mix of burnt umber and country olive on the medium detail brush.

22. Put in the shadow of the fence, and the snow shadows along the track, with a pale wash of cobalt blue.

23. Use the large detail brush to paint shadows on the snowy roof.

24. Use the fan gogh brush to flick up grasses sticking up through the snow with burnt umber.

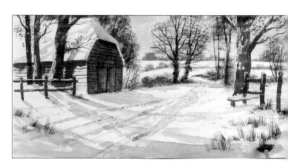

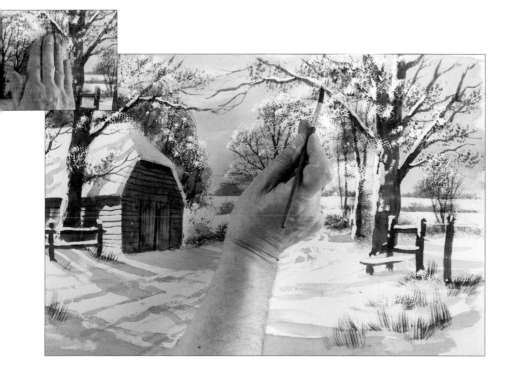

25. Remove the masking fluid with clean fingers. Use the medium detail brush and cobalt blue to touch in shadows on the snow on the branches.

Overleaf
The finished painting.

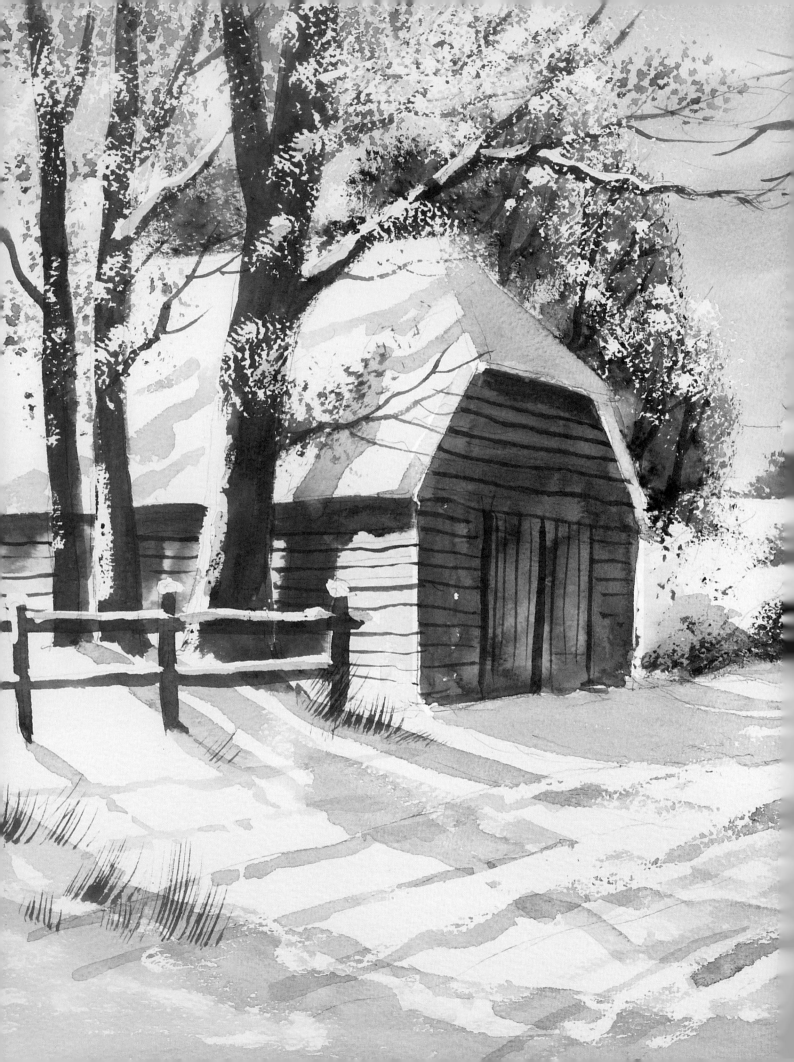

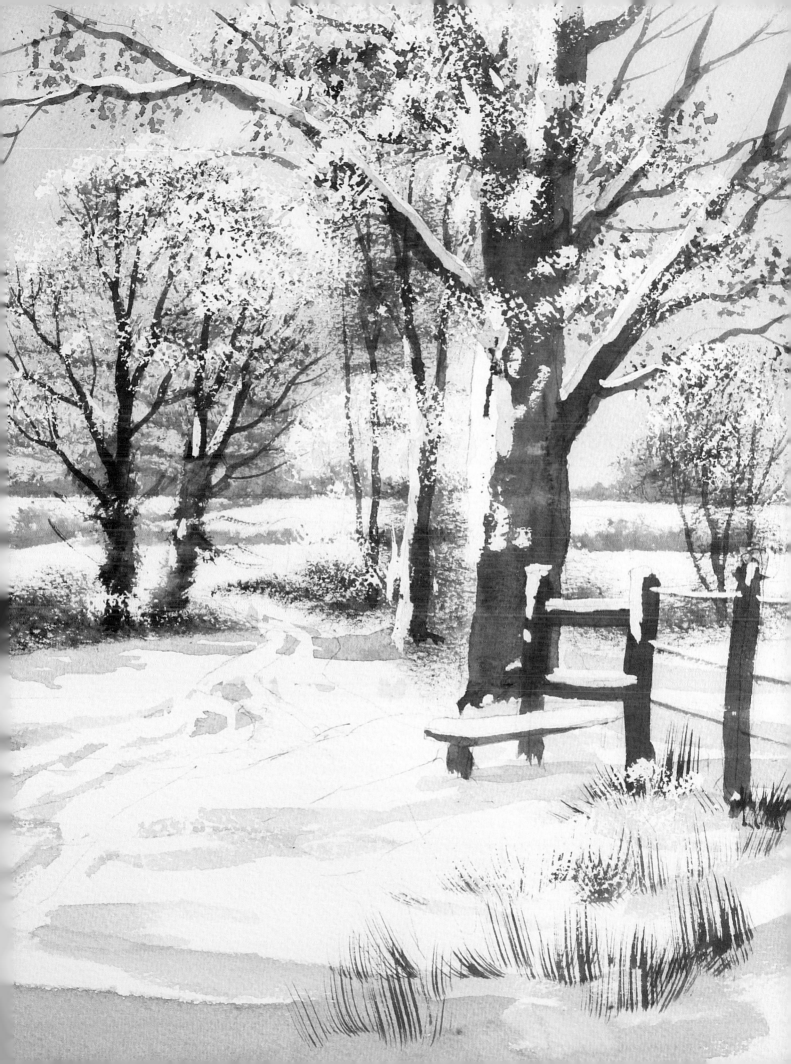

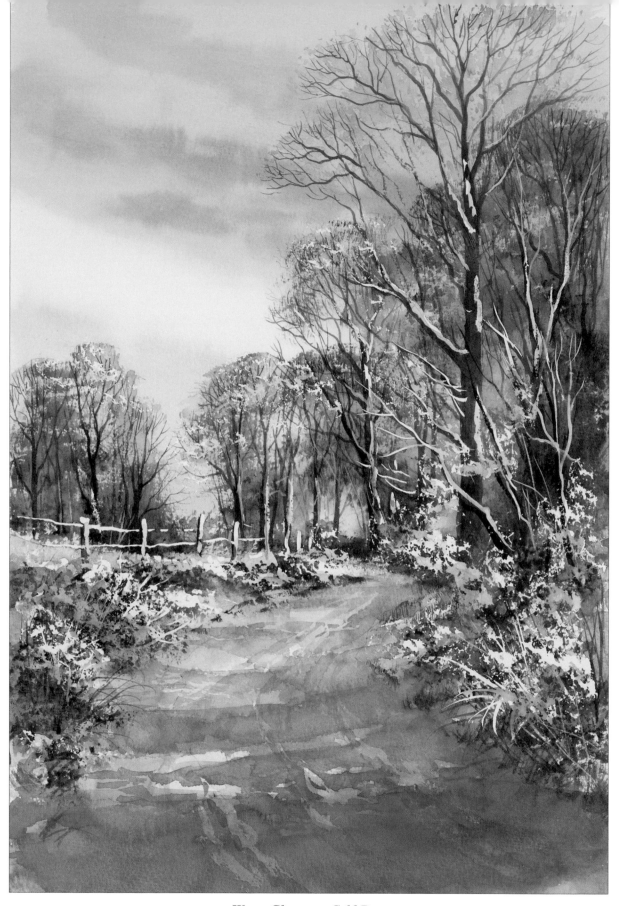

Warm Glow on a Cold Day

Not all winter scenes have to be cold and bleak. Here, the low sun provides the warm colours of a late afternoon sunset. The texture of the snow in the hedgerows was created by applying masking fluid with kitchen paper. Although this is a snow scene, there is very little white or grey.

First Footprints

*The contrast of dark against light makes the snow in the lane appear
crisp and bright. The long shadows in the foreground keep the attention
in the centre of the picture and on the pheasants.*

Lighthouse

Although the lighthouse gets top billing, the breaking wave is the star of this show, and masking fluid is the best technical support. In this painting a selection of brushes are used to good effect: the golden leaf for the sky and the fan gogh for the breaking wave. The stippler px is used to create the foam in the surf and the shingle on the beach. For the rest of the painting the small, medium and large detail brushes are used.

You will need

2B pencil

Masking fluid and masking fluid brush

Kitchen paper

Golden leaf, large detail, half-rigger, stippler px, medium detail, small detail, fan gogh and large detail brushes

Paints – see page 16

Masking tape

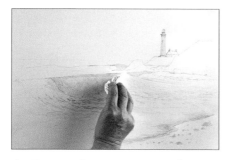

1. Draw the scene. Mask the lighthouse, ripples, undersides of the waves, surf and stones on the beach with masking fluid and a special brush. Dip a flat pad of kitchen paper in masking fluid and dab it on to create foam.

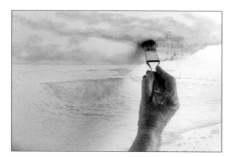

2. Wet the sky area with the golden leaf brush and clear water and paint raw sienna in the lower part of the sky. While this is wet, paint clouds with ultramarine.

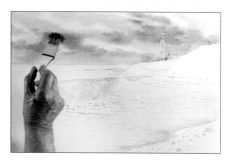

3. Paint dark clouds with ultramarine and burnt umber. Allow to dry.

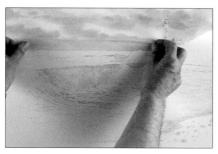

4. Place masking tape above the horizon, over the dried sky.

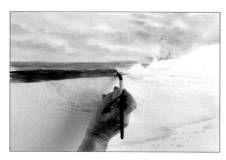

5. Paint the sea with the large detail brush and ultramarine and midnight green, up to the tape. Paint the trough behind the foaming wave with a darker mix.

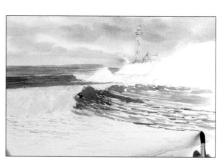

6. Use the same brush and mix to paint the water beneath the foaming wave, creating the shape of the wave with your brush strokes. Leave white paper showing to suggest surf.

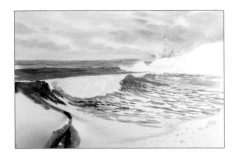

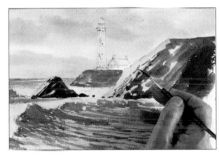

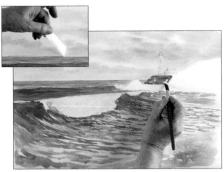

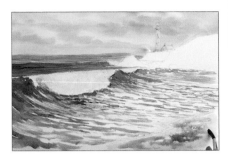

7. Continue painting rippled water, and paint the darker parts of the wave on the left.

8. Paint the beach with a wash of raw sienna, then drop in burnt sienna wet into wet.

9. Remove the masking tape carefully. Paint the rocks beneath the lighthouse with cobalt blue and burnt umber.

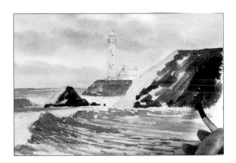

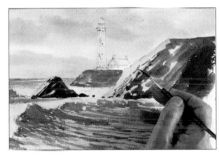

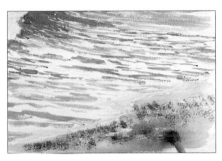

10. Paint the cliff and middle distance rock with raw sienna, then paint burnt umber and ultramarine on top, leaving a little white for foam. Allow to dry.

11. Use the half-rigger to paint finer details on the cliff and rock, with the same mix.

12. Stipple texture on the beach with the stippler px and burnt umber.

13. Change to the medium detail brush and add shade under the ridge of the middle distant wave with horizontal strokes.

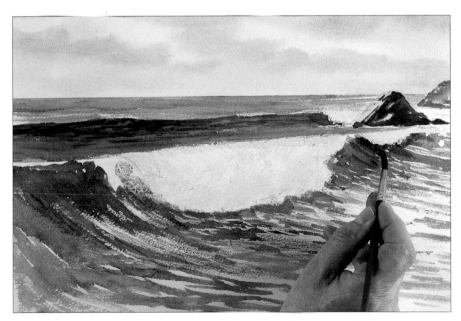

14. Paint the same dark colour under the crest of the breaking wave.

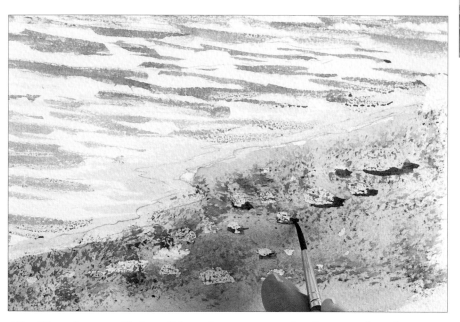

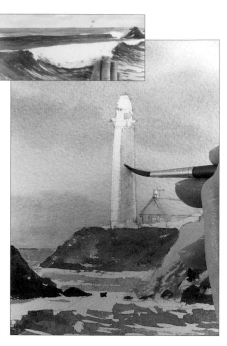

15. Use the small detail brush to paint shadow under the stones on the beach with burnt umber and ultramarine. Allow to dry.

16. Shade the side of the lighthouse with cobalt blue.

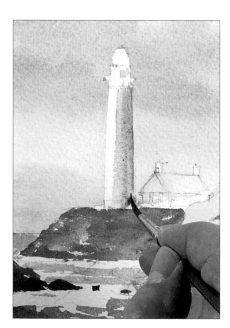

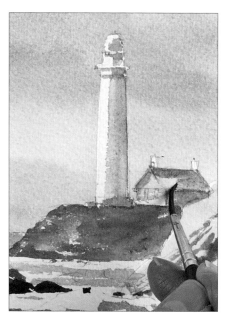

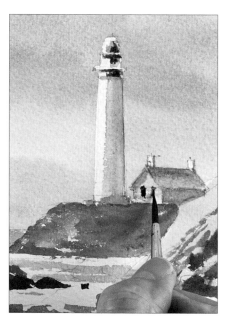

17. While the first wash is wet, drop in burnt umber and cobalt blue. This will soften in, helping to create a cylindrical look.

18. Paint the roof of the house on the right of the lighthouse with a pale wash of burnt umber, then add shade to the house with burnt umber and cobalt blue.

19. Use ultramarine and burnt umber to paint the dark details of the lighthouse and the windows of the house.

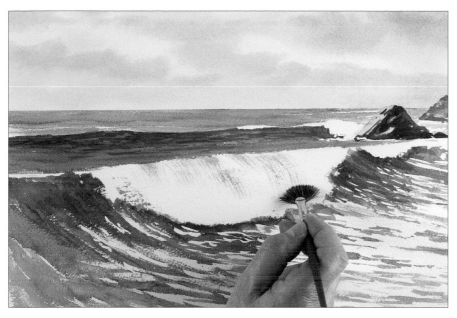

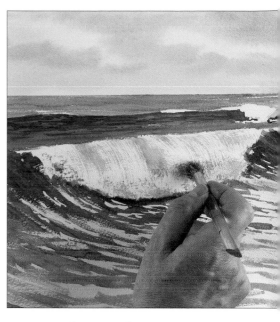

20. Mix cobalt blue with a touch of midnight green and use the fan gogh to brush this down the breaking wave to suggest pouring water.

21. Use the stippler px to stipple cobalt blue into the foam, creating detail.

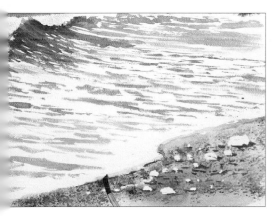

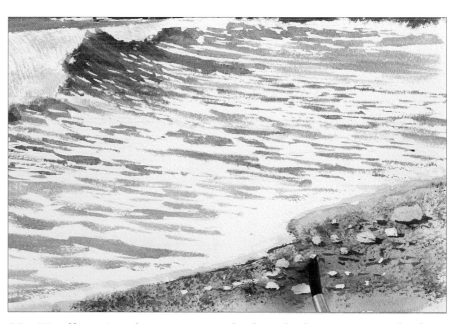

22. Change to the medium detail brush to shade the surf at the waterline with a thin wash of cobalt blue.

23. Finally paint the stones on the beach that were masked out with a wash of raw sienna and the large detail brush.

Overleaf
The finished painting.

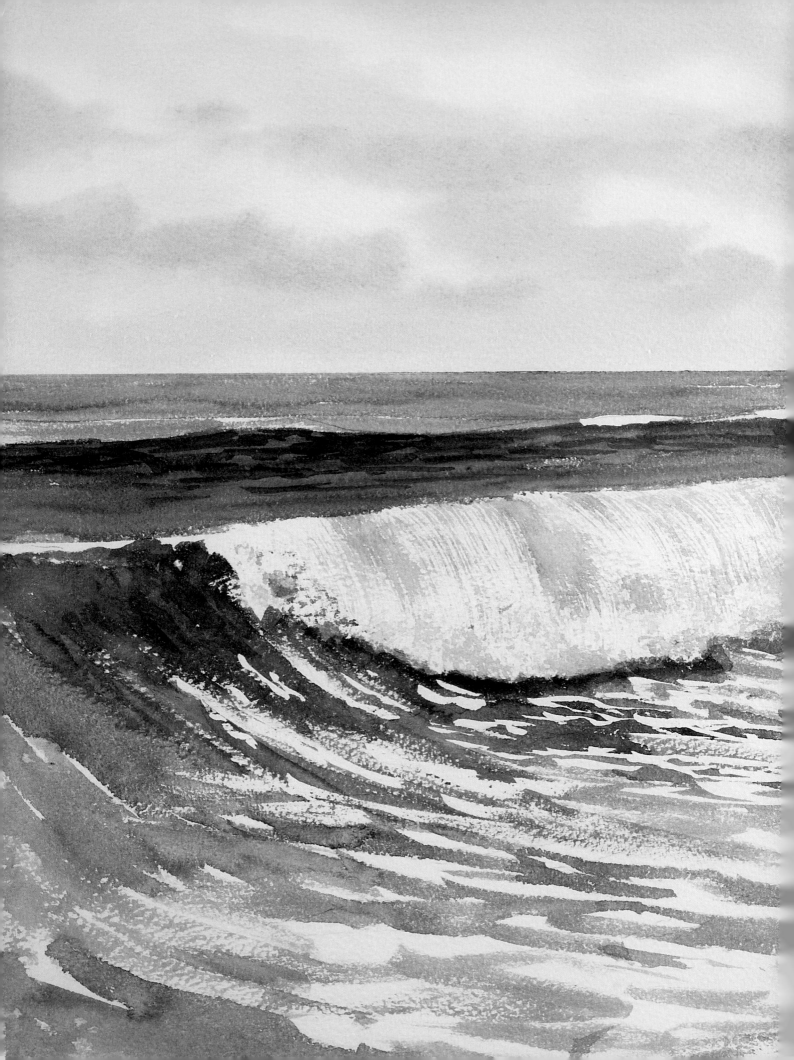

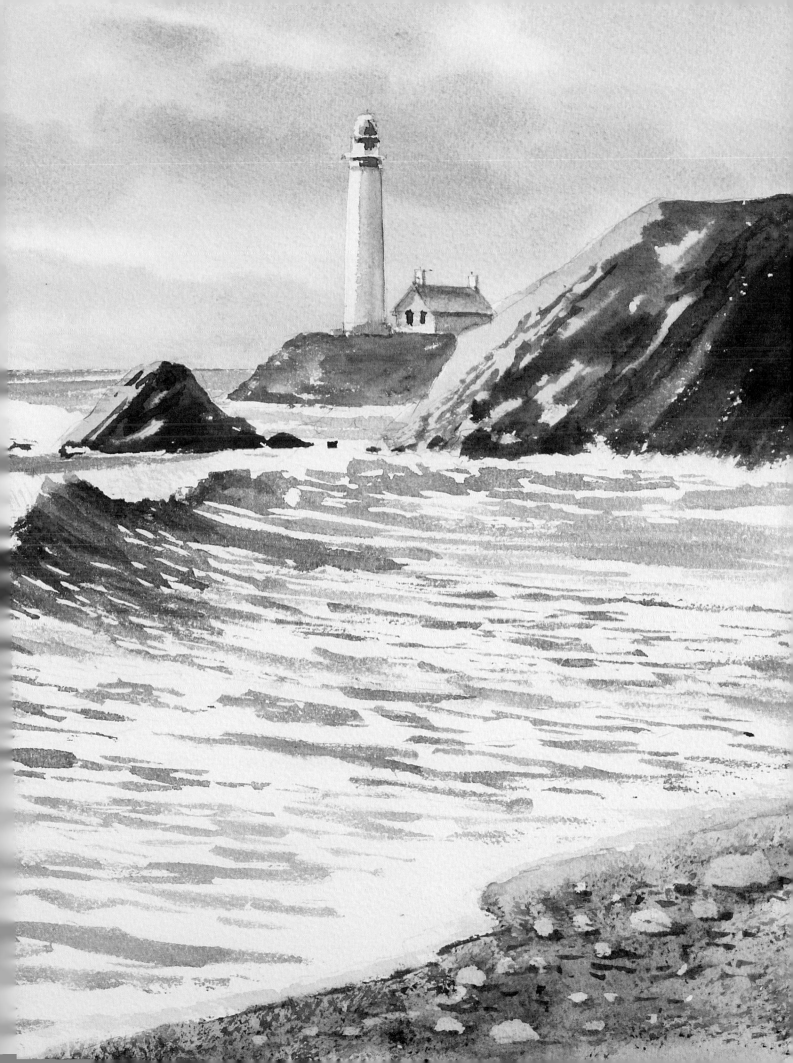

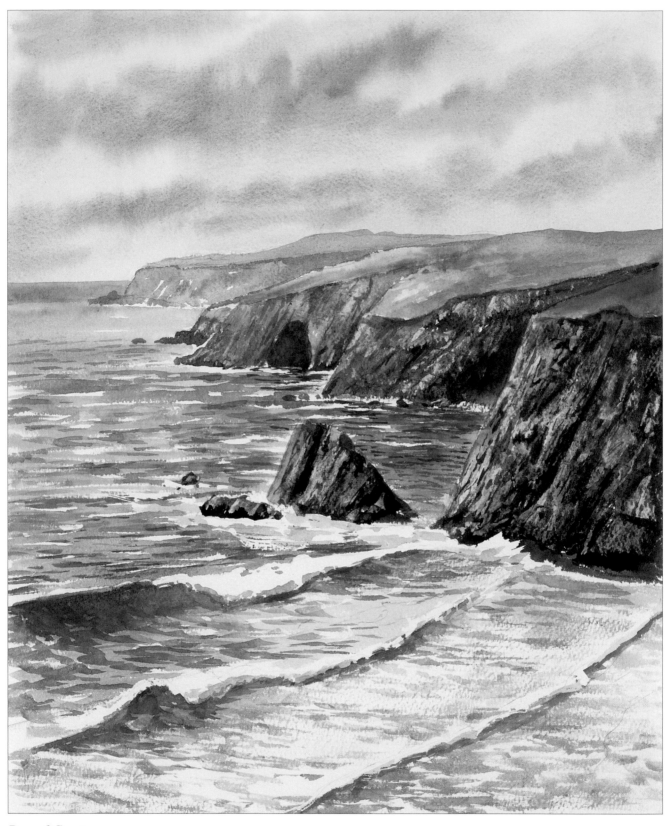

Rugged Coast

To create depth in this painting, the distant headland was painted first with pale, light colours with a hint of blue. The next cliff was painted slightly darker and so on, coming forward to the nearest cliffs and rocks in the foreground. The texture on the cliffs was created by scraping off the paint using a plastic card and the dry brush technique.

110

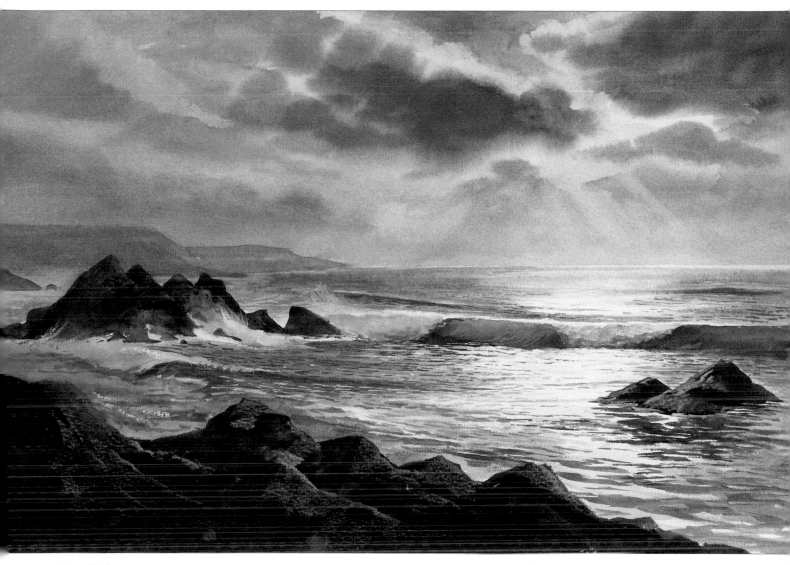

Moonlit Bay

A full moon over the bay with waves crashing on to the seashore – how romantic! Only three colours were used in this painting: burnt umber, ultramarine and midnight green. The lightest shades are in the distance, with the darker tones towards the foreground. To create the rays of light in the sky, I wet them first and then dabbed with kitchen paper to lift some of the colour out. The moonlight on the sea was captured by using the dry brush technique and masking fluid.

Woodland Scene

One of my favourite subjects to paint is a summer wood with a stream, which is not as difficult as it might first appear. Once the background colours are painted, the tree trunks are placed over it. If you look closely at the trees, you will see that there are very few branches showing, making this a very simple step-by-step demonstration.

You will need

2B pencil

Masking fluid and masking fluid brush

Ruling pen

Golden leaf, small detail, medium detail, half-rigger, stippler px, fan gogh and emperor 19mm (¾in) flat brushes

Paints – see page 16

1. Draw the scene. Use masking fluid with a special brush to mask the right-hand side of the foreground tree, the flowers, the rocks and some ripples. Flick up grasses using a ruling pen.

2. Use the golden leaf brush to stipple cobalt blue into the background.

3. Stipple on cadmium yellow wet into wet, then mix cobalt blue and cadmium yellow and stipple this green mix over some of the foliage. Vary the mix.

4. Mix country olive and cobalt blue and stipple this on the woodland floor.

5. Paint the furthest part of the distance in the same way with cobalt blue and a touch of cadmium yellow.

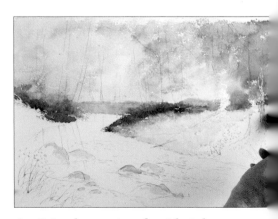

6. Stipple a mix of midnight green and cobalt blue down the stream banks on both sides, then stipple cadmium yellow and raw sienna down to the water's edge.

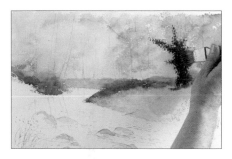

7. Create the shape of one of the tree trunks by stippling on ivy with midnight green.

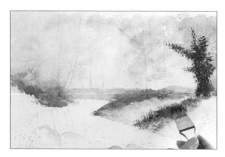

8. Use the same colour to paint shadow from the tree going across the bank, and flick up grasses.

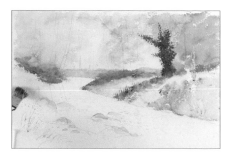

9. Stipple country olive around the foreground tree, then a mix of sunlit green and raw sienna on both sides of the stream.

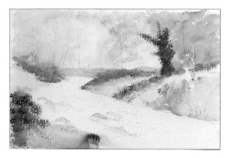

10. Stipple midnight green on the left-hand bank, then sunlit green and raw sienna in the foreground.

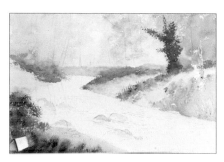

11. Flick up midnight green grasses in the foreground, and allow to dry.

12. Mix cobalt blue and country olive and stipple foliage on the far right.

13. Use the small detail brush and a pale mix of cobalt blue and a touch of country olive to paint distant tree trunks and branches, working upwards from the ground.

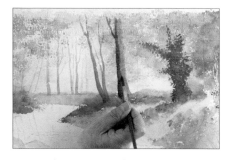

14. Change to the medium detail brush and add a little burnt umber to the mix to paint the trees that are slightly nearer, so that they are thicker and darker in tone. While this is wet, shade the left-hand sides with a darker mix.

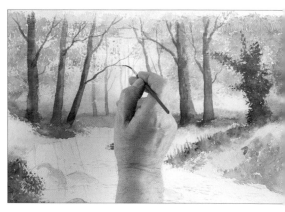

15. Continue adding middle distant trees, and shading them, then paint finer branches with the half-rigger.

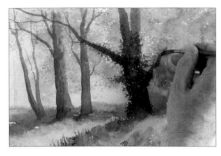

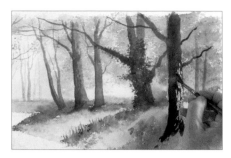

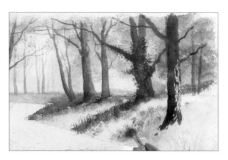

16. Add more burnt umber to the mix and use the medium detail brush to add branches to the ivied tree.

17. Paint the large foreground tree with country olive, burnt umber and ultramarine, going over the foreground.

18. Use the stippler px with country olive to stipple texture in the shade of the trees.

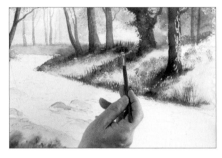

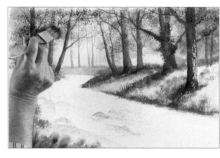

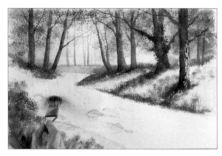

19. Change to the fan gogh and use country olive and a touch of burnt umber to paint grasses under the trees and along the water's edge.

20. Use the golden leaf brush to stipple midnight green and country olive over the foliage area.

21. Paint the water by dragging down a thin wash of cobalt blue, then while this is wet, drop in and drag down cadmium yellow.

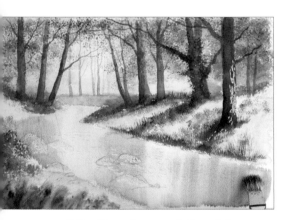

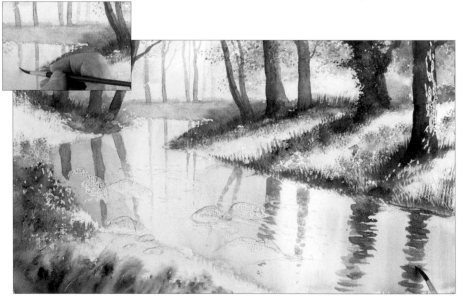

22. Continue adding blue and yellow reflections, ending with a darker wash of cobalt blue on the right. Allow to dry.

23. Paint the reflections of the distant trees with the small detail brush and cobalt blue and country olive, then add a little burnt umber and paint reflections of nearer trees with the medium detail brush. Break up some of the reflections to suggest ripples. Allow to dry.

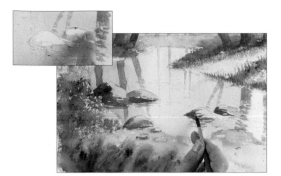

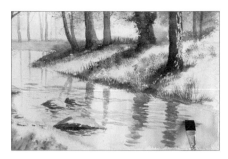

24. Remove the masking fluid from the rocks with clean fingers. Paint the rocks with a pale wash of raw sienna and cobalt blue. Allow to dry, then paint the darker parts with ultramarine and burnt umber.

25. Add rippled reflections with the same mix and little horizontal strokes.

26. Use the edge of the emperor 19mm (¾in) flat brush with a mix of cobalt blue and sunlit green to paint little horizontal ripples.

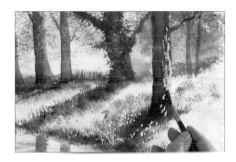

27. Remove the remaining masking fluid. Use the medium detail brush with raw sienna and country olive to paint the highlit parts of the foreground tree.

28. Wash sunlit green over the previously masked grasses, then touch in cobalt blue among the white flowers.

29. Paint orange flowers with a mix of cadmium red and cadmium yellow.

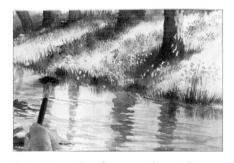
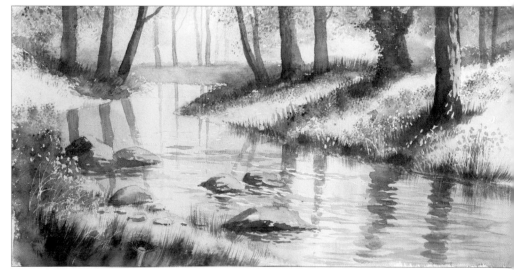

30. Use the fan gogh with country olive to flick up grasses at the water's edge, and drag down the colour into the water to create reflections.

31. Finally, flick up more grasses in the foreground.

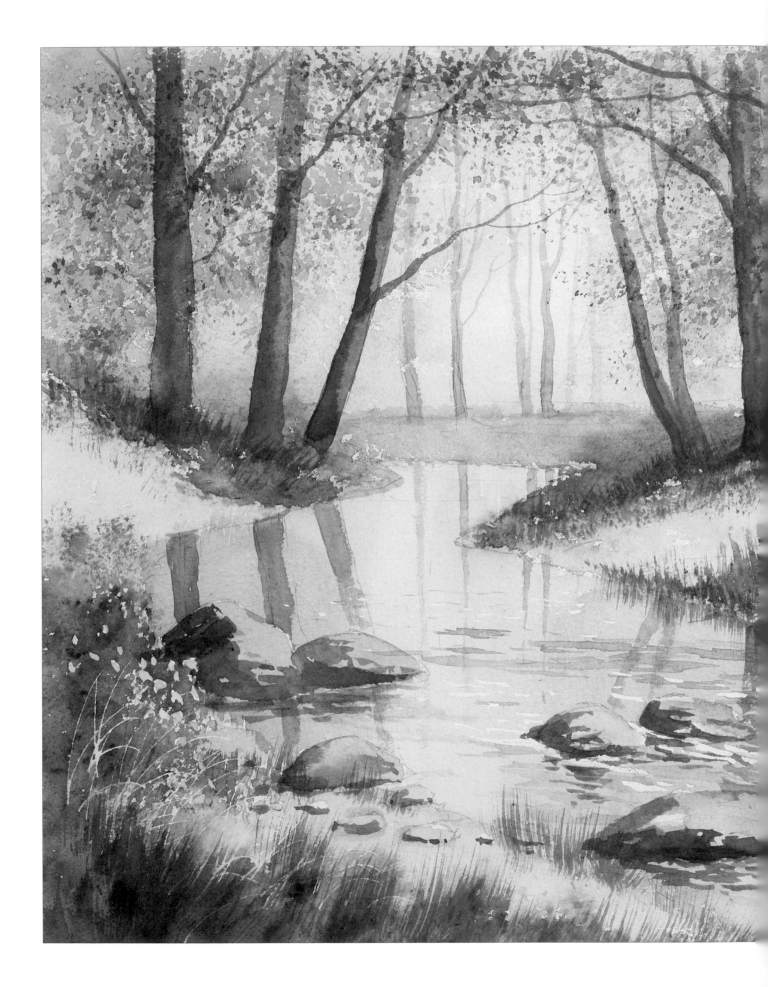

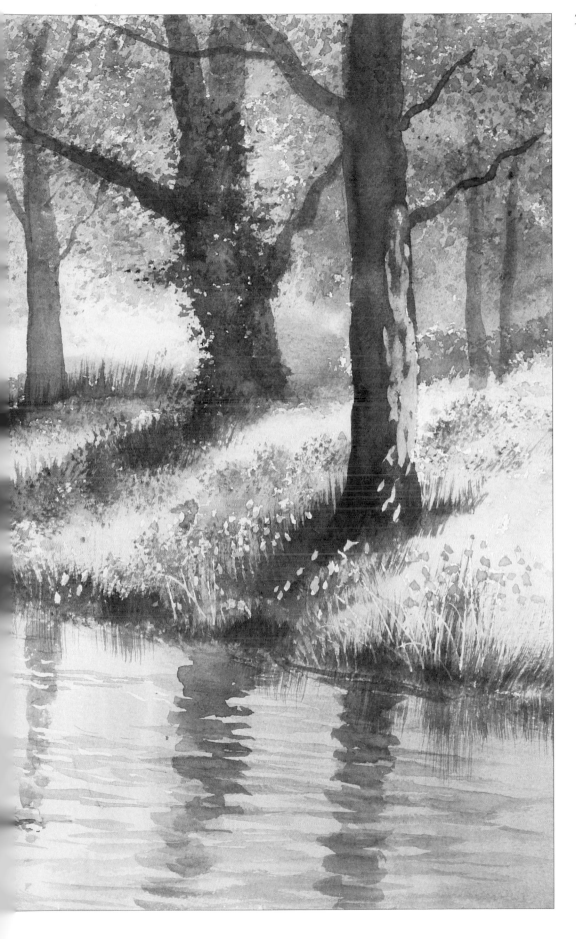

The finished painting.

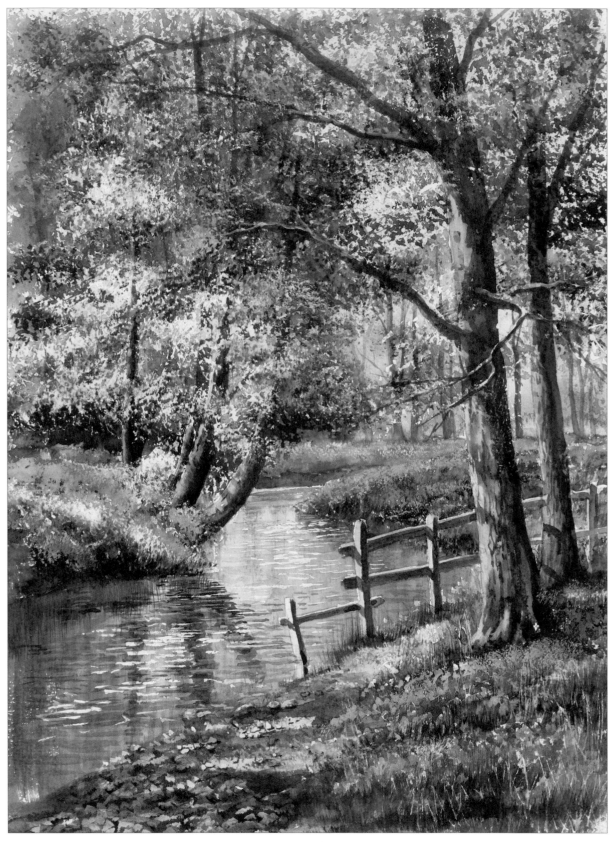

The Secret Bluebell Wood
The sunlit foliage on the trees was created by applying masking fluid, using the same technique as for the snow on the trees shown on page 74. The colours used for the bluebells are permanent rose and cobalt blue, applied using the stippler px brush.

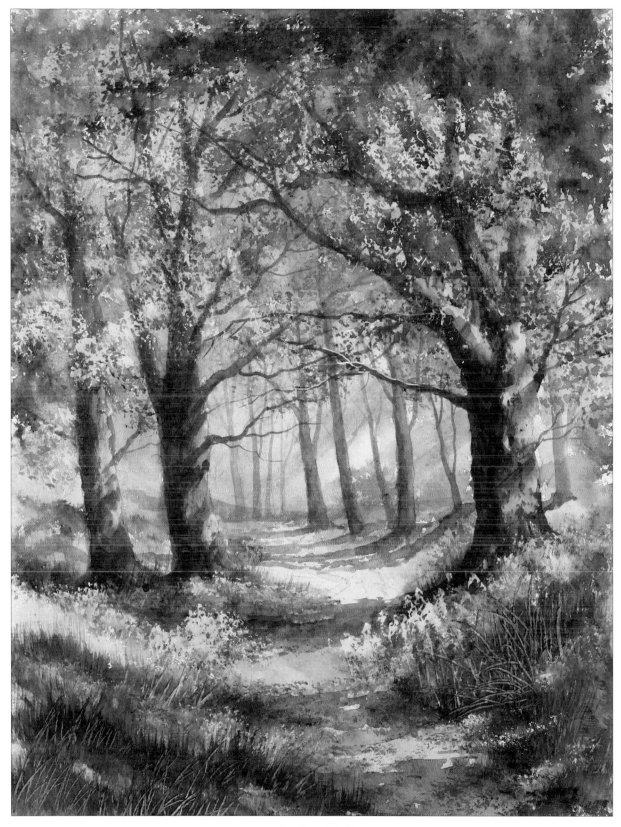

Woodland Path

This painting is very similar to the step-by-step demonstration, but instead of the water, a footpath is the vehicle to lead you through the painting. I used a sponge to apply masking fluid to the foliage and undergrowth. The grasses in the foreground were scraped away using the handle of the stippler px.

Anne Hathaway's Cottage

Anne Hathaway might well have been married to William Shakespeare but she is probably better known for her cottage, which is situated just outside Stratford-upon-Avon. This delightful timber-framed thatched cottage features a garden bursting with flowers behind a white picket fence – a real treat to paint.

You will need

2B pencil

Masking fluid and masking fluid brush

Golden leaf, fan stippler, stippler px, wizard, large detail, medium detail and small detail brushes

Paints – see page 16

Scrap paper for paper mask

1. Draw the scene and use masking fluid and a special brush to mask the fence, gate and some flowers.

2. Wet the sky area with the golden leaf brush and clean water, painting round the building. Wash raw sienna over the lower sky, then dab on ultramarine wet into wet.

3. Stipple the trees in the background with the fan stippler and cobalt blue with midnight green. Use a paper mask to mask off the edge of the cottage roof.

4. Use the warmer green, country olive, to stipple the trees slightly further forwards.

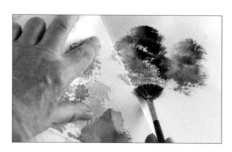

5. Load the left-hand side of the brush with sunlit green and the right-hand side with midnight green, and stipple the trees on the right of the cottage, again using a paper mask to mask the roof.

6. Stipple dark midnight green foliage next to the cottage, then sunlit green on the right, and country olive over the masked fence.

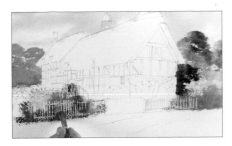

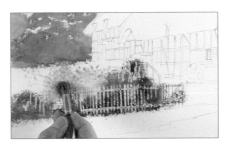

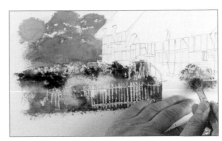

7. Use the stippler px with midnight green to stipple over the masked flowers and the fence. Continue stippling, alternating between midnight green, sunlit green and country olive.

8. Stipple raw sienna over the garden.

9. Continue stippling the foliage of the garden with midnight green and then sunlit green. Mask the wall with a paper mask.

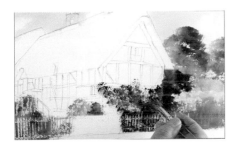

10. Paint country olive and a little midnight green over the end of the cottage, making it dark over the fence to create a contrast.

11. Use the wizard and raw sienna to paint the central areas of the thatched roofs. This will give a glow to the thatch.

12. Mix ultramarine and burnt umber. Paint carefully over the ridges of the roofs and then drag the colour down over the raw sienna. Allow to dry.

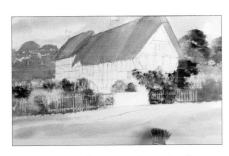

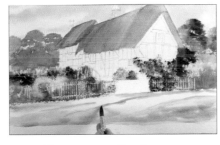

13. Paint the road with the golden leaf brush and raw sienna, then brush in a little burnt sienna.

14. Change to the large detail brush and drop in shadow colour wet into wet, allowing it to soften, suggesting dappled sunlight, shadow and car tracks.

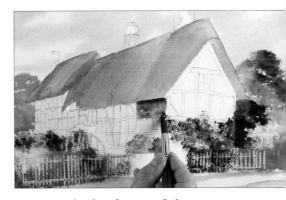

15. Wash the front of the cottage with a very pale mix of burnt sienna and burnt umber, then suggest the brickwork at one end with burnt sienna. While this is wet, drop in shadow under the eaves wet into wet.

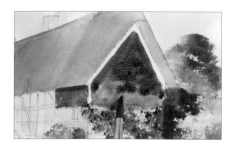

16. Paint the gable end in the same way, with burnt sienna and then shadow dropped in wet into wet.

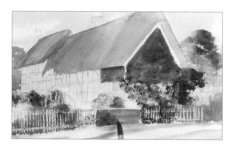

17. Use a mix of burnt sienna and a touch of shadow to paint the brick wall, then drop in burnt umber wet into wet.

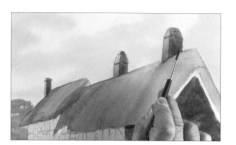

18. Wash burnt sienna over all three chimney pots with the medium detail brush. Allow to dry, then use the small detail brush to paint details and shade on the right-hand sides with shadow.

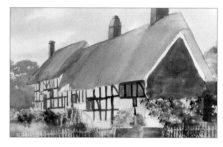

19. Paint the dark woodwork and the windows with a mix of ultramarine and burnt umber, making it stronger towards the foreground.

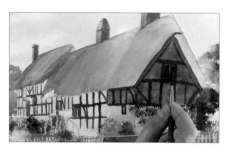

20. Use the medium detail brush to paint the shadow under the thatch with the same mix, then add the woodwork and window.

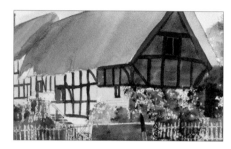

21. Paint the steps and the shadow behind the foliage with a pale mix of the same colours.

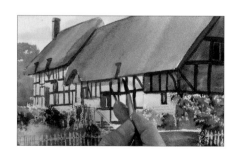

22. Use the small detail brush to paint the dormer windows in the thatch, then change back to the medium detail brush to paint the shadow under the eaves with the same mix. Extend the shadow lower with a thin wash of the colour shadow.

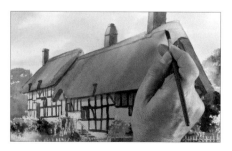

23. Shade the gable end of the thatch and then paint the ridges at the top of the roofs with shadow.

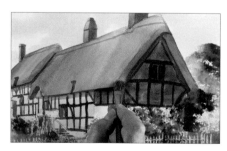

24. Mix shadow with burnt umber and use a fairly dry wizard brush to darken the edge where the thatch rolls over, creating texture. Allow to dry.

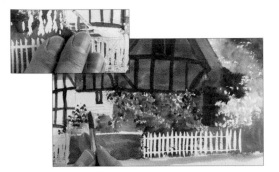
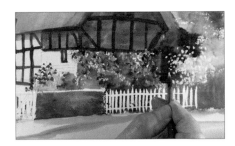
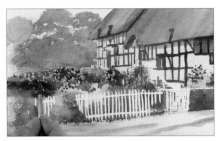

25. Remove all the masking fluid with clean fingers. Paint flowers with the medium detail brush and cadmium yellow, permanent rose and cadmium red.

26. Paint hollyhocks with cobalt blue, then more flowers with permanent rose, then mix permanent rose and cobalt blue to create a violet colour, and cadmium red and cadmium yellow to make orange.

27. Use thick cadmium red to paint opaque flowers over the dark foliage.

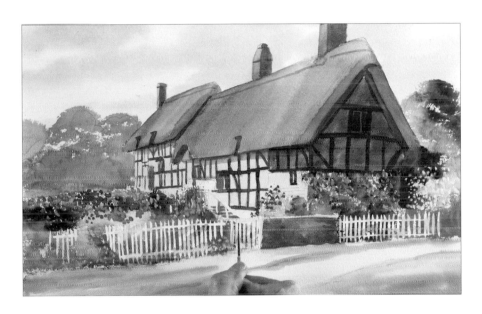

28. Soften the whiteness of the fence by washing a little cobalt blue over it to suggest shadow. Make the gate stand out by painting cobalt blue and burnt umber behind it using the half-rigger.

29. Finally paint tree trunks and branches with a mix of cobalt blue and country olive.

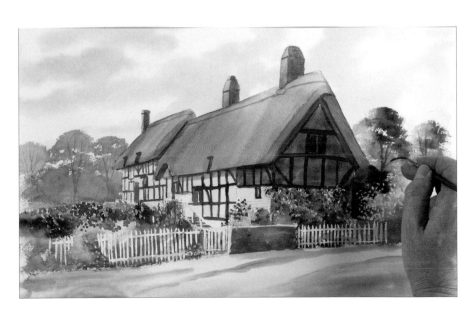

The finished painting.

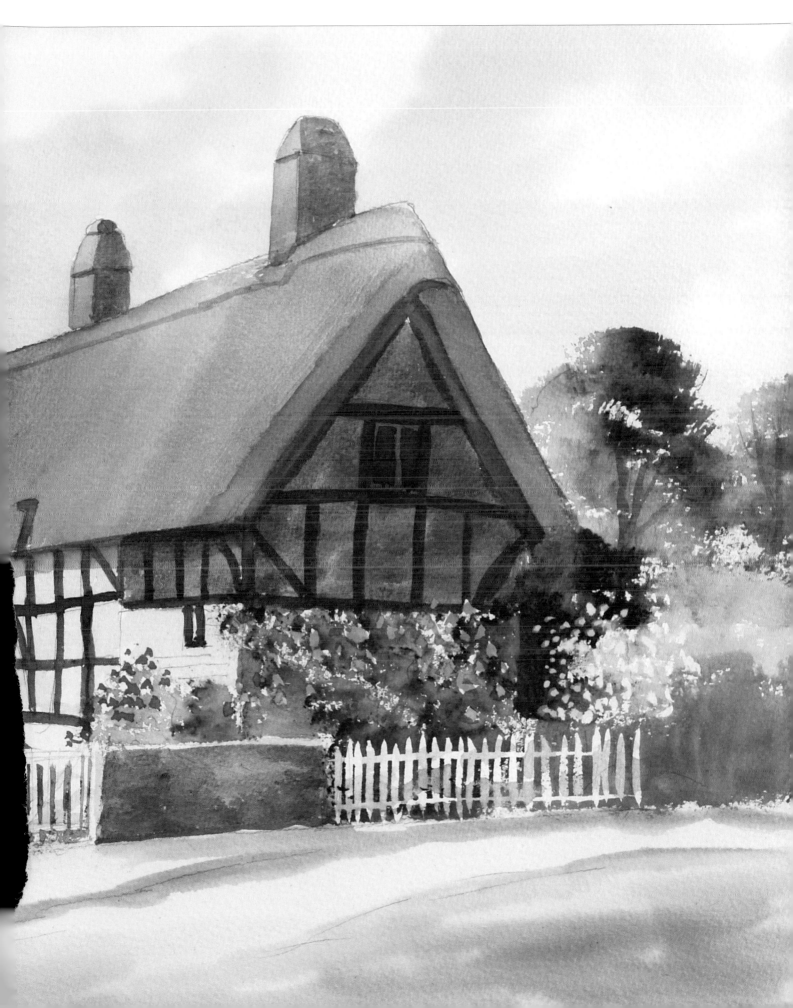

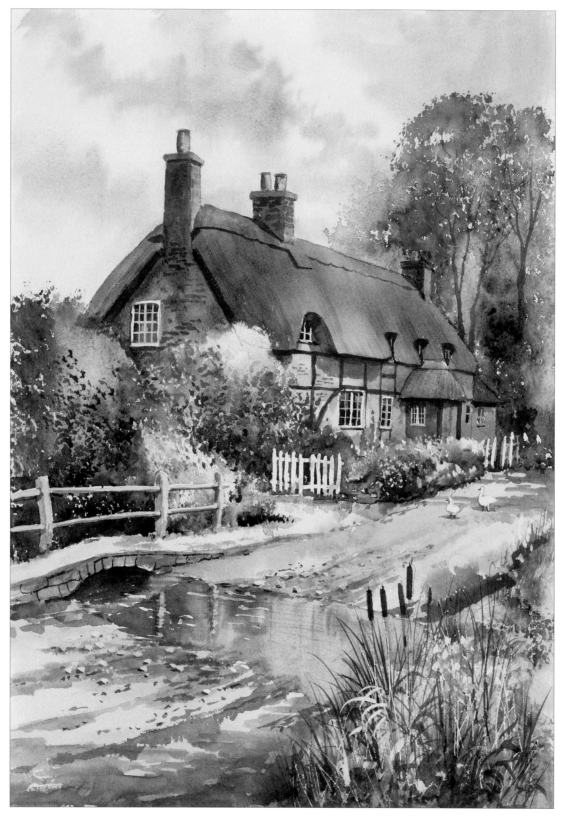

Ford Cottage

The cottage and gardens supply the colour and the interest in this quaint study. The stream across the lane would form a barrier but the eye and the viewer are helped over the water by the footbridge. The bulrushes point the way to the focal point in the centre of the painting. I have added some life in this painting in the form of a pair of ducks waddling in the lane.

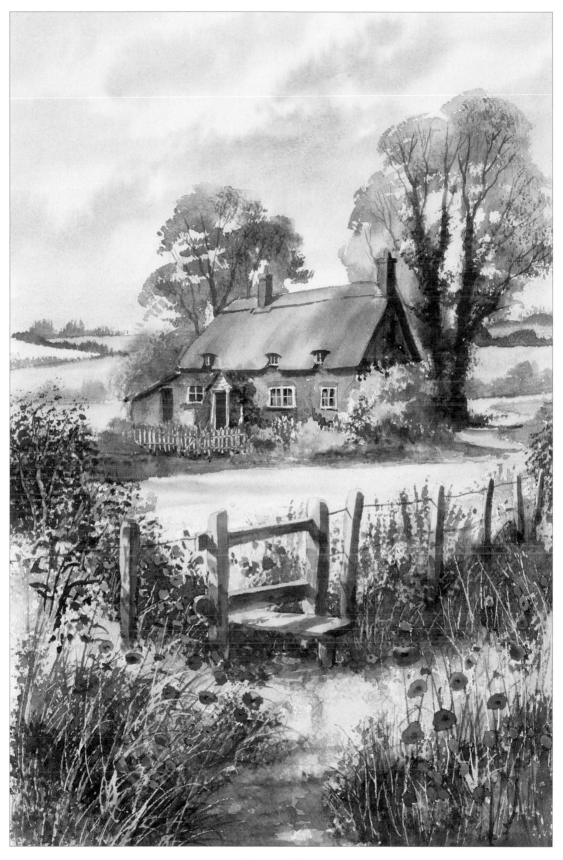

Shortcut Home
The footpath and stile lead you into the painting, and once over the stile,
you are rewarded with a delightful view of the cottage down the lane.

Index